# Patron Saints

Project Manager: Eric Himmel
Editor: Aiah R. Wieder
Designer: Sandra DiPasqua
Production Manager: Anet Sirna-Bruder

Library of Congress Cataloging-in-Publication Data

Calamari, Barbara.
  Patron saints : a feast of holy cards / by Barbara Calamari and Sandra DiPasqua.
    p. cm.
  ISBN-13: 978-0-8109-9402-7 (hardcover)
  ISBN-10: 0-8109-9402-X (hardcover)
  1.  Christian patron saints. 2.  Holy cards.  I. DiPasqua, Sandra. II. Title.

  BX4656.5.C35 2007
  282.092'2—dc22

               2007003842

Printed and bound in China
10 9 8 7 6 5 4 3 2 1

harry n. abrams, inc.
a subsidiary of La Martinière Groupe

115 West 18th Street
New York, NY 10011
www.hnabooks.com

# Patron Saints

barbara calamari & sandra dipasqua

ABRAMS, NEW YORK

Acknowledgments There are many people we need to thank for help on this book. First off, we are grateful to Editor-in-Chief Eric Himmel for accepting this, our third project with Harry N. Abrams. The staff there have been extremely helpful and generous with their time. Mark LaRiviere, Design Director, and Anet Sirna-Bruder, the VP of Production, worked extremely hard to ensure the visual integrity of this book. Our research entailed combing through a myriad of sources and compiling thousands of names, lists, and dates of some very obscure historical characters. Aiah Wieder, our editor, spent many grueling hours fact-checking the minute details of this information. She not only did an excellent job, but she has the patience of a saint. We also need to thank our agent, Jim Fitzgerald, for his enthusiasm and belief in this project.

We are extremely grateful to Dan Wilby for photographing the holy cards and to Konstantin Dzhibilov for his Photoshop skills. Deborah Rust has also been a great help to us. Pat Bates and Louis Turchioe were always there when we needed them.

We loved working on this book and are truly proud of the results. Without Father Eugene Carrella, pastor of Saint Adalbert's Parish in Staten Island, New York, none of this would have been possible. His amazing collection of holy cards could fill hundreds of books. As ever, our most difficult task was editing down the images. We are truly lucky to count him as a friend as well as coworker.

In our research, we came across hundreds, maybe thousands of patron saints and patronages we could not include due to shortage of space. Since our initial glossary was over twenty-eight pages long, we had to settle for dividing the patronages into five topics and presenting a broad list of saints under each topic. We apologize to any saint, living or dead, whom we omitted.

This book is dedicated to our siblings: Deborah DiPasqua Williams, Guy DiPasqua, Kathleen Daly, Raymond Calamari, and Patricia Calamari.

✢

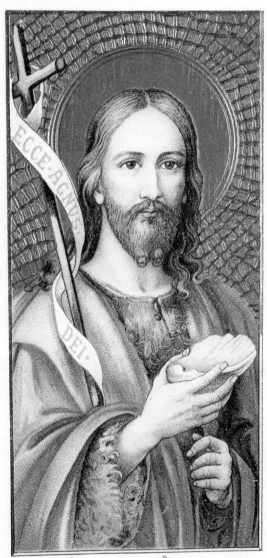

ST. JOANNES BAPTISTA.

# Contents

# Introduction

There are more than ten thousand saints in the Catholic calendar. They hail from all corners of the world, as well as every social class and ethnic group. They have all suffered from human faults, made terrible mistakes, endured illnesses, and borne disappointments both large and small. Some were great rulers and leaders, traveling the world; many never left the towns and cities where they were born, toiling in dull, quiet lives.

The first saints recognized were martyrs, people who died for their faith. Early Christians considered it an honor to build their houses of worship near the execution and burial grounds of these first saints. Churches were named for saints out of respect, designating the patron of that church, and it was common for the faithful to petition them in prayers. Since the martyrs had died in imitation of Christ, Christians believed that they too had reached a place in Heaven, where they would not forget their friends and followers on Earth, and that they would make strong advocates before God. Eventually, sainthood was bestowed on any person who lived a life of extraordinary spiritual discipline and holiness. Often, these people accomplished feats far beyond the capacities of the average person and became the subjects of entertaining stories, usually told in visual form. These holy people have only recently gained formal recognition from Church authorities through the complicated process of canonization. It is important to note the Church does not make saints—it only recognizes them. There are countless individuals who might qualify for the title of saint but remain unknown.

Since holiness is an energy that transcends all boundaries and does not weaken and disappear as material things do, Catholics believe that the saints exist on a spiritual plane and have a very real presence in the world today. In life, saints served as human examples of what one could achieve by using Christ's precepts of universal love, and they continue to guide and aid the living in the afterlife by praying with and for them upon request. Every Catholic has a patron saint who functions as a guide or mentor throughout their earthly existence.

The word "patron" derives from the Latin word *patronus*, which means "protector of clients" or "defender." The intercession of a patron saint is thought to help speed the efficacy of one's prayers before God. There are many ways to find one's patron saint, although the most common way is through one's name. Children are often named in honor of a relative, who in turn was named for a saint. In this way, the saint serves as an ancestral guide through life, connecting several generations of a family. Others claim their patron saint by matching their own day of birth with a saint's feast day, which commemorates the day of a saint's death. Details or themes of a saint's story or image might resonate with a person's life. The saint's

birthplace or the area where a saint lived can inspire allegiance. Many people find common ground with a patron through the practice of a similar occupation, in the sharing of an illness, or in the endurance of a similar state of life.

Representing an immense range of human experience, the stories of holy people related in this book span over two thousand years of history. Because it is common practice for Catholics to carry images of their patron in holy card form, we have chosen to illustrate this book solely with these images. We have divided the patronages of these saints into five basic categories: Health, Nations, Nature, Occupations, and States of Life. In the instances where a saint has multiple patronages that span across these categories, we list all their other areas of support. With the help of Father Eugene Carrella, pastor of Saint Adalbert's Church in Staten Island, New York, we have selected the images we found most intriguing and unusual from his spectacular collection of rare holy cards. Many of the saints we profile are obscure; others, like Saint Anthony of Padua, traditionally known as the finder of lost objects, are depicted in an unusual way (in the image we found, he is reattaching the limb of a legless boy, and he is listed as the patron of amputated limbs). The images themselves date from the late seventeenth to early twentieth century. Produced by printers in Belgium, Germany, Austria, Italy, France, and Switzerland, they tend to depict every saint with a European visage, regardless of the saint's actual racial origins.

Saints can enjoy both local and global popularity. Some are well-known in particular regions of the world and totally unknown in others. Their traditional patronages are derived from details about their lives, birthplaces, occupations, or visual iconography. There is no official or comprehensive index of saints; rather, there is a myriad of sources listing saints and their patronages. For this book, if we found a saint listed with a particular patronage in three different sources, we included him or her in our compilation. As new occupations and illnesses appear, Church authorities will sometimes put them under the patronage of an existing saint. For example, Saint Clare of Assisi, who lived in the thirteenth century, became the patron saint of television due to her ability to envision distant events. Saints venerated during the plague are also called upon to help those suffering from AIDS. As new nations are recognized, saints who worked in those parts of the world will be taken as national patrons.

Having full access to Father Carrella's extraordinary collection has enabled us to create this second book of holy cards images for Abrams. Originally developed as a way for Catholics to carry images of their patrons as one would carry a family photograph, holy cards are a perfect visual complement to this personal—yet universal—subject.

✝

# Saints of Health

AIDS sufferers and caregivers: Aloysius Gonzaga, Peregrine Laziosi, Thérèse of Lisieux alcoholism: John of God, Martin of Tours, Matthias the Apostle, Monica, Urban of Langres amputees: Anthony of Padua, Anthony the Abbot angina: Swithbert appendicitis: Erasmus arm pain: Amalburga arthritis: Alphonsus Maria de Liguori, Colman, James the Greater, Killian, Servatus, Totnan bacterial infection: Agrippina blindness: Catald, Cosmas, Damian, Deochar, Dunstan of Canterbury, Lawrence the Illuminator, Leodegarius, Lucy of Syracuse, Lutgardis, Odilia, Parasceva of Rome, Raphael the Archangel, Thomas the Apostle breast diseases: Agatha broken bones: Drogo, Stanislaus Kostka bruises: Amalburga burns: Catherine of Siena, John the Apostle cancer: Aldegundis, Ezekiel Moreno y Diaz, Giles, James Salomone, Peregrine Laziosi childbirth: Erasmus, Gerard Majella, Leonard of Noblac, Lutgardis, Margaret of Antioch, Raymond Nonnatus chills: Placid cholera: Roch colds: Maurus, Sebaldus colic: Agapitus, Charles Borromeo, Emerentiana, Erasmus, Liborius compulsive gambling: Bernadine of Siena consumption: Panteleon, Thérèse of Lisieux contagious diseases: Roch convulsions: John the Baptist, Willibrord convulsive children: Guy of Anderlecht, John the Baptist, Scholastica coughing: Blaise, Quentin, Walburga cramp: Cadoc of Llancarvan, Maurice, Pancras deafness: Cadoc of Llancarvan, Drogo, Francis de Sales, Meriadoc, Ouen of Rouen depression: Amabilis, Benedict Joseph Labre, Bibiana, Christina the Astonishing, Drogo, Dymphna, Eustochium of Padua, Fillan, Giles, Job, Margaret of Cortona, Maria Fortunata Viti, Medard, Michelina, Osmund, Raphaela, Romanus of Condat, Veran dizziness: Ulric drug addiction: Maximilian Kolbe dying: Abel, Barbara, Benedict, Catherine of Alexandria, James the Lesser, John of God, Joseph, Margaret of Antioch, Michael the Archangel, Nicholas of Tolentino, Sebastian dysentery: Lucy of Syracuse, Polycarp of Smyrna earache: Cornelius, Polycarp of Smyrna eczema: Anthony the Abbot, George, Marculf, Peregrine Laziosi, Roch epilepsy: Alban of Mainz, Anthony the Abbot, Apollinaris, Balthasar, Bibiana, Catald, Christopher, Cornelius, Dymphna, Genesius of Rome, Gerard of Lunel, Giles, Guy of Anderlecht, John Chrysostom, John the Baptist, Valentine of Rome, Vitus, Willibrord eye diseases: Aloysius Gonzaga, Augustine of Hippo, Clare of Assisi, Cyriacus, Deochar, Erhard of Regensburg, Herve, Leodegarius, Lucy of Syracuse, Odilia, Raphael the Archangel, Symphorian of Autun fainting: Urban of Langres, Ursus of Ravenna, Valentine of Rome fever: Abraham, Adelard, Amalberga, Andrew Abellon, Antoninus of Florence, Benedict, Castorus, Claudius, Cornelius, Dominic of Sora, Domitian of Huy, Genevieve, Gerebernus, Gertrude of Nivelles, Hugh of Cluny, Jodocus, Liborius, Mary of Oignies, Nicostratus, Peter the Apostle, Petronilla, Radegunde, Raymond Nonnatus, Severus of Avranches, Sigismund, Simpronian, Theobald Roggeri, Ulric, Winnoc fistula: Fiacre food poisoning: John the Evangelist foot problems: Peter the Apostle, Servatus gallstones: Benedict, Drogo, Florentius of Strasburg, Liborius goiters: Blaise gout: Andrew the Apostle, Apollinaris, Colman, Erconwald of London, Gerebernus, Gregory the Great, Killian, Maurice, Maurus, Totnan handicapped people: Alphais, Angela Merici, Gerard of Aurillac, Germaine Cousin, Giles, Henry II, Lutgardis, Margaret of Castello, Seraphina, Servatus, Servulus hangovers: Bibiana head injuries: John Licci headaches: Acacius of Byzantium, Anastasius the Persian, Bibiana, Denis, Dionysius the Aeropagite, Gerard of Lunel, Gereon, Pancras, Stephen the Martyr, Teresa of Ávila, William Firmatus heart ailments: John of God, Teresa of Ávila hemorrhage: Bernardine of

Siena, Lucy of Syracuse, Margaret of Antioch hernia: Alban of Mainz, Catald, Conrad of Piacenza, Cosmas, Damian, Drogo, Gummarus herpes: Willibrord hoarseness: Bernadine of Siena, Maurus infertility: Agatha, Anne, Anthony of Padua, Casilda of Toledo, Felicity, Francis of Paola, Gerard Majella, Giles, Henry II, Margaret of Antioch, Medard, Philomena, Rita of Cascia, Theobald Roggeri inflammatory diseases: Benedict insanity: Amabilis, Benedict Joseph Labre, Bibiana, Christina the Astonishing, Drogo, Dymphna, Eustocium of Padua, Fillan, Giles, Job, Margaret of Cortona, Maria Fortunata Viti, Medard, Michelina, Osmund, Raphaela, Romanus of Condat, Veran insect bites: Mark the Apostle intestinal diseases: Brice, Charles Borromeo, Emerentiana, Erasmus, Timothy, Wolfgang invalids: Roch jaundice: Odilo kidney stones: Alban of Mainz, Liborius kidney diseases: Benedict, Drogo, Margaret of Antioch, Ursus of Ravenna knee problems: Roch labor pains: Anne leg diseases: Servatus leprosy: Genevieve, George, Giles, Lazarus, Radegunde, Vincent de Paul lumbago: Lawrence, Willibrord lung diseases: Bernardine of Siena migraines: Gereon, Severus of Avranches, Ubaladus Baldassini miscarriage: Catherine of Siena, Catherine of Sweden muteness: Drogo neurological disorders: Bartholomew the Apostle, Dymphna, Vitus open sores: Peregrine Laziosi plague: Adrian of Nicomedia, Catald, Colman of Stockerau, Cuthbert, Edmund of East Anglia, Erhard of Regensburg, Francis of Paola, Francis Xavier, Genevieve, George, Gregory the Great, Macarius of Antioch, Roch, Sebastian, Valentine of Rome, Walburga poisoning: Amabilis, Benedict, John the Apostle, Pirmin polio: Margaret Mary Alacoque pregnancy: Anne, Anthony of Padua, Dominic of Silos, Elizabeth, Gerard Majella, Joseph, Margaret of Antioch, Raymond Nonnatus, Ulric prolonged suffering: Lydwina of Schiedam pulmonary diseases: Agatha, Aloysius Gonzaga, Bernadine of Siena rabies: Denis, Dominic de Silos, Guy of Anderlecht, Hubert of Liège, Otto of Bamburg, Sithney, Walburga rheumatism: Alphonsus Maria de Liguori, Colman, James the Greater, Killian, Servatus, Totnan running sores: Peregrine ruptures: Drogo, Florentius of Strasburg, Osmund scrofula: Balbina, Cadoc, Marculf, Mark the Evangelist sick children: Beuno, Pope Clement I, Hugh of Lincoln, Ubaldo Baldassini skin diseases: Anthony the Abbot, George, Marculf, Peregrine Laziosi, Roch sleep disorders: Vitus smallpox: Matthias the Apostle, Rita of Cascia snakebite: Hilary of Poitiers, Patrick, Paul the Apostle, Vitus spasms: John the Baptist stammering: Notkar Balbulbus sterility: Agatha, Anne, Anthony of Padua, Casilda of Toledo, Felicity, Fiacre, Francis of Paola, Giles, Henry II, Margaret of Antioch, Medard, Philomena, Rita of Cascia, Theobald Roggeri stiff neck: Ursicinus of Saint-Ursanne stomach disorders: Brice, Charles Borromeo, Emerentiana, Erasmus, Timothy, Wolfgang stroke: Andrew Avellino, Wolfgang syphilis: Fiacre, George, Symphorian of Autun throat diseases: Andrew the Apostle, Blaise, Etheldreda, Godelieve, Ignatius of Antioch, Lucy of Syracuse, Ludmila, Swithbert toothache: Apollonia, Christopher, Elizabeth of Hungary, Ida of Nivelles, Kea, Medard, Osmund twitching: Bartholomew the Apostle, Cornelius typhus: Adelard ulcers: Charles Borromeo, Job, Radegunde venereal diseases: Fiacre whooping cough: Blaise, Winnoc wounds: Aldegundis, Marciana, Rita of Cascia

The shadow of illness looms over every life. Since saints have suffered from, conquered, or died of every possible medical condition, those suffering from similar ailments frequently turn to them for aid in their prayers. Among saints with health patronages are those who have been ill themselves as well as those who are great healers. Frequently, iconography and stories of martyrdom play a part in the designation of patrons of health. Saint Agatha is the patron of breast diseases because her breasts were cut during her martyrdom. Similarly, Saint Lucy of Syracuse lost her eyes, and she is therefore invoked for vision problems. As Saint Stephen the Martyr was stoned to death and is always pictured with stones, he is invoked against kidney stones.

✣

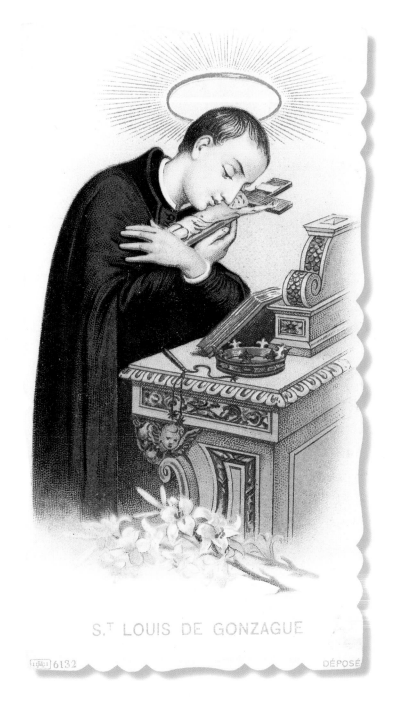

S.ᵀ LOUIS DE GONZAGUE

6132                    DÉPOSÉ

## AIDS Sufferers & Caregivers / Aloysius Gonzaga, 1568–1591, Feast Day: June 21

A courtier and a soldier devoted to the Virgin Mary. Against his family's wishes, he became a Jesuit novice at the age of eighteen. Despite the fact that he himself suffered from a kidney disease, he insisted on tending the sick when the plague struck Rome. He died of the plague at the age of twenty-two.

**Other patronages:** pulmonary diseases; teenagers

**Invoked:** for help in choosing a state of life; against lust

✠

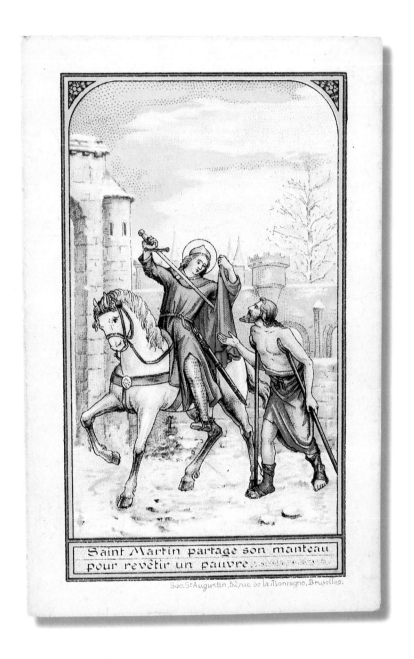

Saint Martin partage son manteau
pour revêtir un pauvre.

Soc. St Augustin, 52, rue de la Montagne, Bruxelles.

## ALCOHOLISM / MARTIN OF TOURS, 316–397, FEAST DAY: NOVEMBER 11

Born into a Hungarian military family, Martin was named for Mars, the Roman god of war. As a soldier, he converted to Christianity and was elevated to the office of bishop by the people of Tours. It is said he could turn water into wine, and he died on the day when the new wine is traditionally tasted. Immensely popular for his charity, he is known as the "Thirteenth Apostle."

**Other patronages:** geese, horses; cavalrymen, cloth merchants, innkeepers, potters, tanners, vine growers, vintners; beggars, oppressed people

**Invoked:** against poverty

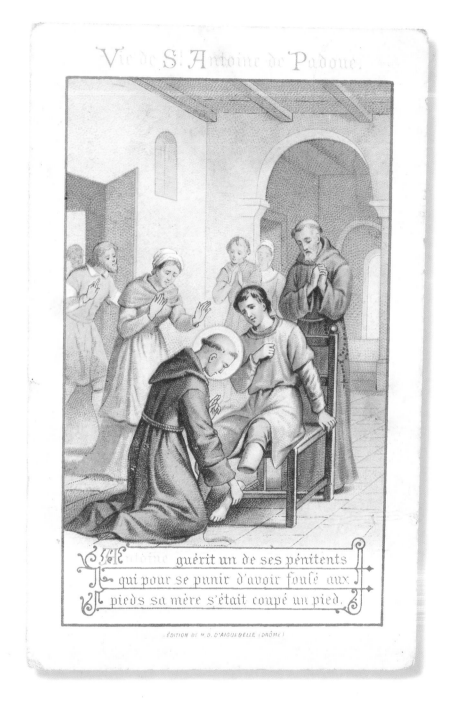

Vie de St. Antoine de Padoue.

S.t Antoine guérit un de ses pénitents
qui pour se punir d'avoir foulé aux
pieds sa mère s'était coupé un pied.

ÉDITION DE N.D. D'AIGUEBELLE (DRÔME)

**AMPUTEES / ANTHONY OF PADUA, 1195–1231, FEAST DAY: JUNE 13**

A Franciscan preacher known as "the Wonder Worker," Anthony is one of the most popular saints in the world. In one of the many miracle stories about him, when a boy kicked his mother in front of the saint, his foot came off. Anthony reattached it after the boy apologized.
**Other patronages:** Portugal; draftees, potters, seamen, sellers of strawberries; barren women, orphans, prisoners, shipwrecked people
**Invoked:** to find lost articles, a husband; against infertility

Let us do with all our heart the duty
of each day.

58

P. IN WITZERLAND

**ARTHRITIS / ALPHONSUS MARIA DE LIGUORI, 1696–1787, FEAST DAY: AUGUST 1**

Turning his back on an extremely successful law career, Alphonsus de Liguori entered religious life and founded the Order of Redemptorists. Dedicated to ministering to the poor and downtrodden, he was the author of over seventy books. He suffered from crippling arthritis throughout his life and achieved much despite his illness.

**Other patronages:** confessors, moral theologians

✝

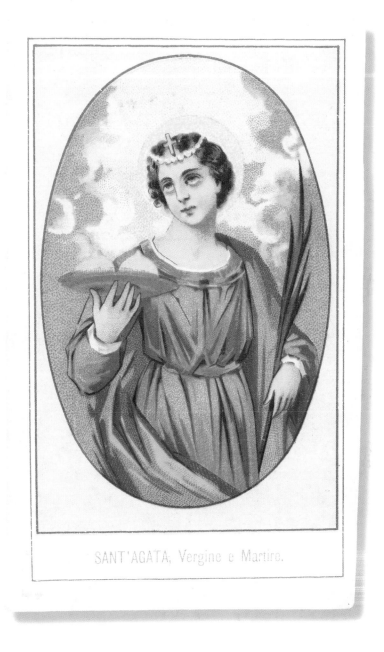

SANT'AGATA, Vergine e Martire.

## BREAST DISORDERS / AGATHA, D. 251, FEAST DAY: FEBRUARY 5

A virgin martyr from Catania, Sicily, Agatha is closely identified with the protection of her homeland. When she refused to renounce her Christian faith, Agatha was tortured by having her breasts cut off. While in prison, Saint Peter came and healed her. She was later killed by being rolled in burning coals. At the same time, a great earthquake shook Catania, destroying her persecutors. Her veil is still used to ward off the eruptions of nearby Mount Etna.

**Other patronages:** Malta; burns, pulmonary diseases; bell ringers, bell makers, brass workers, cloth makers, glass workers, wet nurses; nursing mothers

**Invoked:** against fires, volcanic eruptions

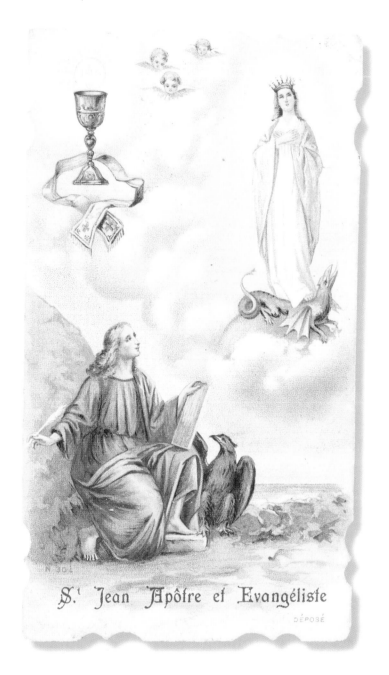

S.ᵗ Jean Apôtre et Evangéliste

DÉPOSÉ

BURNS / JOHN THE APOSTLE, D. 101, FEAST DAY: DECEMBER 27

A witness to the Transfiguration as well as the author of one of the Gospels and the Apocalypse, John is considered to have had great mystical powers. In A.D. 95, the Romans attempted to martyr him by throwing him into a vat of boiling oil. He survived this and was exiled to the island of Patmos for practicing magic.

**Other patronages:** Asia Minor, Turkey; alchemists, artists, bookbinders, booksellers, chandlers, copyists, engravers, fullers, gunsmiths, millers, oil producers, papermakers, printers, theologians, typographers, writers; virgins, widows

**Invoked:** against food poisoning

✝

S. PEREGRINE LAZIOSI
O. S. M.
Patron of malignant growths

## CANCER / PEREGRINE LAZIOSI, 1260–1345, FEAST DAY: MAY 1

An antipapist political leader, Peregrine converted to Catholicism after his violence against the papal legate was rebuffed with kindness. He eventually became a popular preacher, dedicating himself to working with the hopelessly ill. He himself was diagnosed with cancer. The night before he was to have his leg amputated, Christ came to him and healed him in his cell.

**Other patronages:** incurable illnesses, running sores

**Invoked:** for medical breakthroughs

✝

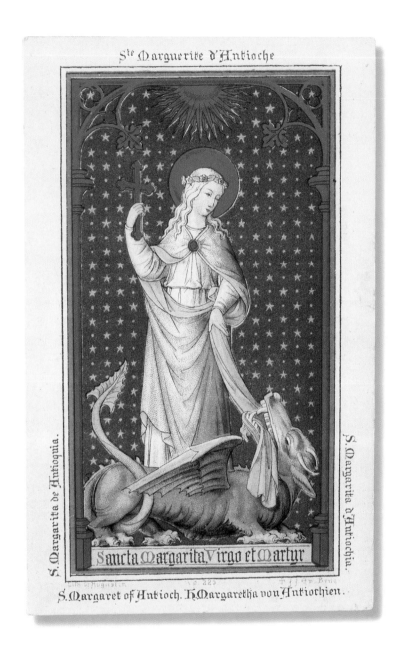

Ste Marguerite d'Antioche

S. Margarita de Antioquia.

S. Margarita d'Antiochia.

Sancta Margarita, Virgo et Martyr

S. Margaret of Antioch. H. Margaretha von Antiochien.

## CHILDBIRTH / MARGARET OF ANTIOCH, LATE THIRD CENTURY, FEAST DAY: JULY 20

Margaret was a beautiful princess who secretly converted to Christianity. She was driven from her home and became a simple shepherdess. When she refused the advances of the local governor, she was imprisoned. The Devil appeared to her as a dragon and swallowed her whole. A cross she was carrying grew until it split the dragon in two, enabling her to climb out.

**Other patronages:** laundresses, midwives, nurses, shepherds; pregnant women

**Invoked:** against hemorrhages, infertility, pains of childbirth, floods, storms

✢

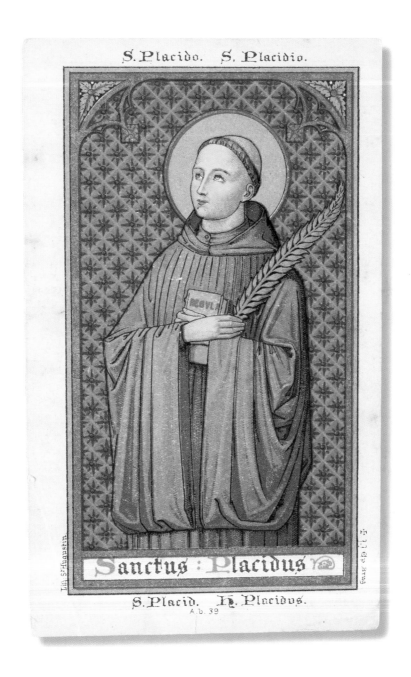

CHILLS / PLACID, 515–541, FEAST DAY: JANUARY 15

Sent to study with Saint Benedict at the age of seven, Placid was saved from drowning in a freezing river when his plight appeared to Benedict in a vision. His father was so grateful at Benedict's intercession that he donated the land for the great Monte Cassino monastery to the Benedictine Order.

**Invoked:** against drowning

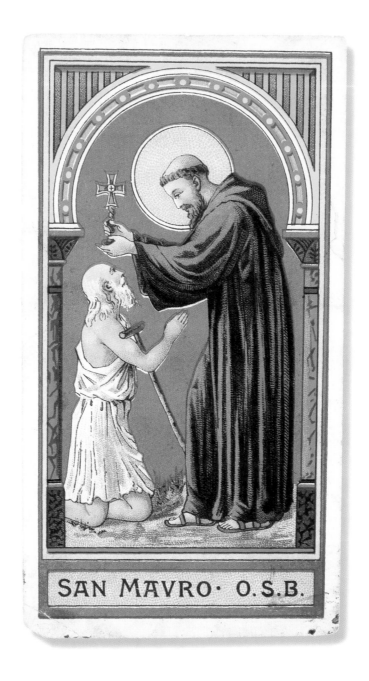

SAN MAVRO · O.S.B.

COLDS / MAURUS, 510–584, FEAST DAY: JANUARY 15

A disciple of Saint Benedict, Maurus was praying with his mentor when Benedict had a vision of a fellow monk, Placid, falling into the freezing river and being carried away by the current. He ordered Maurus to rescue him. Maurus ran across the surface of the water and brought Placid to safety. He later crossed the Alps on foot and founded his own monastery.

**Other patronages:** charcoal burners, coppersmiths
**Invoked:** against chills

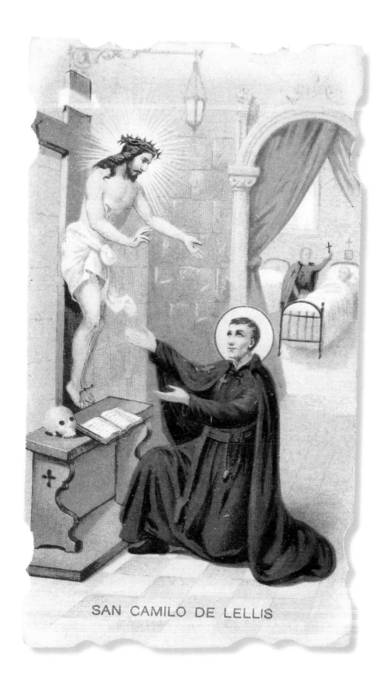

SAN CAMILO DE LELLIS

## COMPULSIVE GAMBLING / CAMILLUS OF LELLIS, 1550–1614, FEAST DAY: JULY 14

A soldier of fortune, Camillus lost everything gambling. To pay off his debts, he worked as a construction worker for the Capuchin monks. He entered their order and was hospitalized for an old war injury. He devoted himself to the care of the sick, founding the nursing order of the Congregation of the Servants of the Sick.

**Other patronages:** care of the sick; nurses

**Invoked:** for a good spiritual death

☩

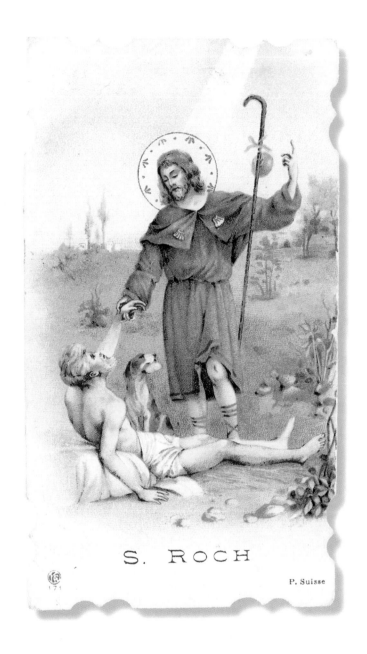

S. ROCH

P. Suisse

## CONTAGIOUS DISEASES / ROCH, 1295–1327, FEAST DAY: AUGUST 16

A religious pilgrim from Montpellier, Roch was known for his ability to heal with the sign of the cross. As he passed through plague-stricken areas, he would stay to heal the sick. When he became ill himself, he went off to die alone so that no one would need to nurse him. A dog cared for and fed him until he recovered.

**Other patronages:** grapevines; dealers in secondhand goods, gravediggers, stoneworkers; bachelors, prisoners

**Invoked:** against cholera, plague, skin diseases

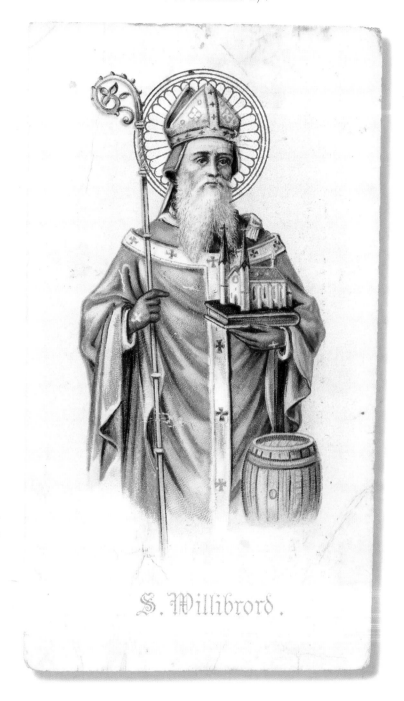

S. Willibrord.

## CONVULSIONS / WILLIBRORD, 658–739, FEAST DAY: NOVEMBER 7

Born in England, Willibrord was a missionary in Denmark and Holland. He died founding a Benedictine monastery in Luxembourg. At his shrine there, a dance procession lasting several hours is performed in honor of his role in ending an epidemic of St. Vitus' dance. The dance consists of three steps forward and five steps back, circling the saint's tomb, and then leaving the church. This dance is also supposed to have curative powers for those with nervous disorders.

**Other patronages:** Luxembourg, the Netherlands
**Invoked:** against chorea, epilepsy, herpes, lumbago

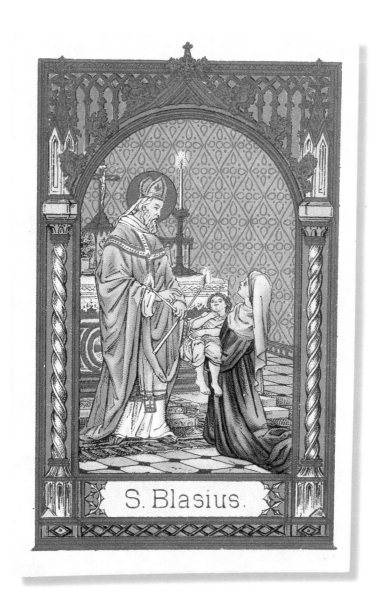

S. Blasius.

### COUGHING / BLAISE, D. 316, FEAST DAY: FEBRUARY 3

An Armenian bishop known for his healing powers, Blaise took refuge in a forest during a time of persecution. When many animals stayed by his side, angry hunters reported him to the authorities. While in prison, he healed a boy choking on a fishbone by praying in his cell. Condemned to death, he then promised to protect all who brought a candle to church on his feast day. He is commemorated on his feast during the "Blessing of the Throats."

**Other patronages:** Croatia; sick cattle, wild animals; builders, carders, laryngologists, mattress makers, swineherds, wind musicians, wool workers

**Invoked:** against goiter, throat diseases

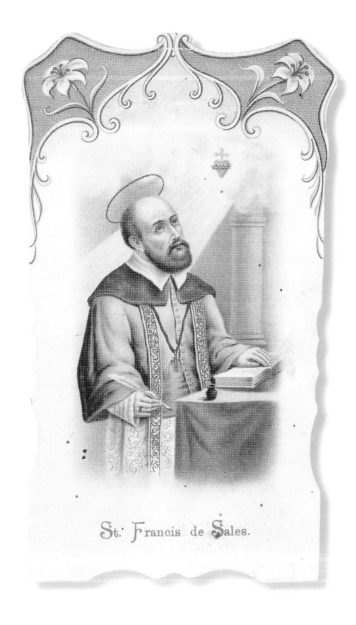

St. Francis de Sales.

**DEAFNESS / FRANCIS DE SALES, 1567–1622, FEAST DAY: JANUARY 24**

A priest with great influence on the laity, Francis wrote the most popular spiritual book of the seventeenth century, *Introduction of the Devout Life*. He is credited with inspiring a resurgence of faith in France and Switzerland. At a time when the deaf were considered mentally deficient, he developed a method of teaching the catechism to a deaf man by using his own set of symbols and sign language.

**Other patronages:** Catholic Press, editors, journalists, writers

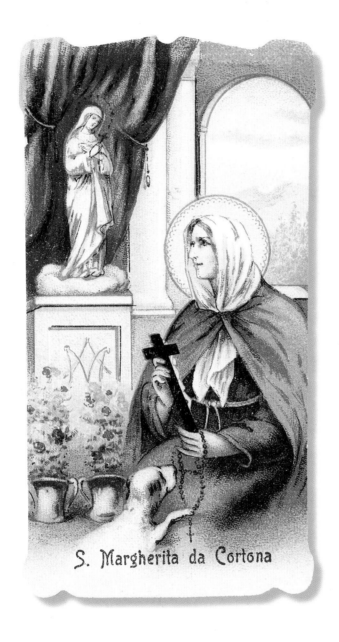

S. Margherita da Cortona

## DEPRESSION / MARGARET OF CORTONA, 1247–1297, FEAST DAY: FEBRUARY 22

A Franciscan tertiary, Margaret had lived with her lover until his murder. Upon her conversion, she struggled with the temptation to return to her former life. She suffered extreme bouts of self-hatred and had to be prevented from self-mutilation. Despite the ridicule and gossip that surrounded her, she was extremely spiritual, experiencing visions of Christ.

**Other patronages:** fallen women, falsely accused people
**Invoked:** against temptation

✝

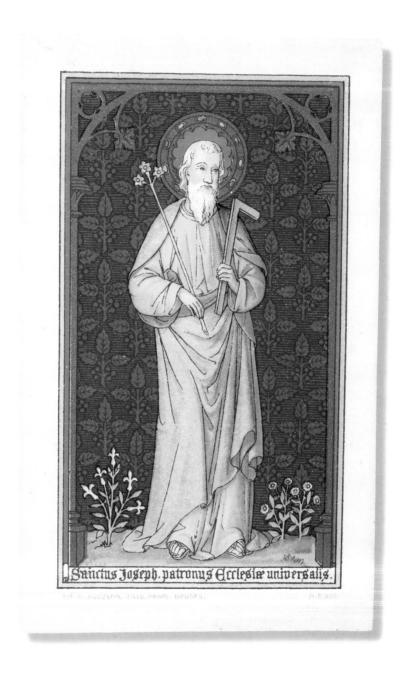

Sanctus Joseph, patronus Ecclesiæ universalis.

DYING / JOSEPH, FIRST CENTURY B.C., FEAST DAY: MARCH 19

Joseph was the carpenter who served as Christ's father on Earth. He never shirked his duties as the head of his family and stood by Mary, guarding her from ridicule and respecting her virgin state. It is thought that Joseph died well before Christ was crucified; hence he never had to suffer over the fate of his son. For this reason, he is invoked for a happy death.

**Other patronages:** Austria, Belgium, Canada, Mexico, Peru, Vietnam; carpenters; fathers

**Invoked:** against doubt; for the sale of a house; to find work

‡

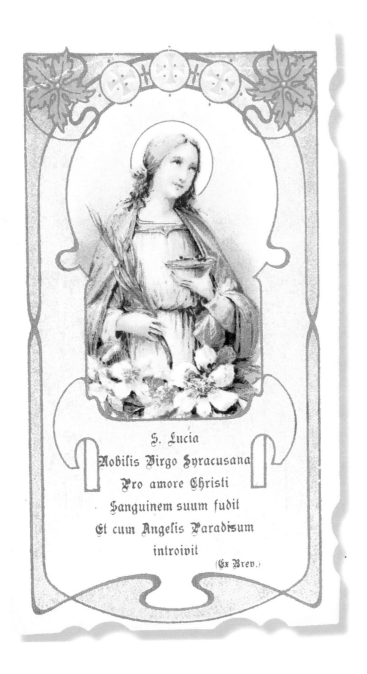

S. Lucia
Nobilis Virgo Syracusana
Pro amore Christi
Sanguinem suum fudit
Et cum Angelis Paradisum
introivit
(Ex Brev.)

## EYE DISEASE / LUCY OF SYRACUSE, 283–304, FEAST DAY: DECEMBER 13

Lucy was a beautiful Christian girl who made a vow of chastity. When a persistent suitor kept praising her eyes, she ripped them out and sent them to him. He then denounced her as a Christian and she was executed by having her throat cut. Since her name means "light," her patronage is extended over all areas of vision, both spiritual and physical.

**Other patronages:** electricians, farmers, oculists; blind people

**Invoked:** against hemorrhages, throat diseases

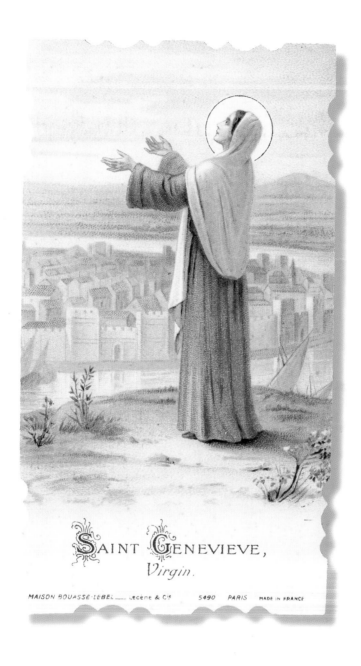

SAINT GENEVIEVE,
*Virgin.*

MAISON BOUASSE-LEBEL ____ Lecène & Cⁱˢ      5490    PARIS    MADE IN FRANCE

## FEVER / GENEVIEVE, 422–500, FEAST DAY: JANUARY 3

This young mystic saved the city of Paris from starvation after an invasion by the Franks. She was so respected by the conquering forces that she converted the king. She later repelled an invasion by Attila the Hun with the power of her prayer. When an unstoppable plague of fever killed many in the city in 1129, a parade of her relics through the streets was credited with ending it.

**Other patronages:** Paris; the Women's Army Corps; chandlers, shepherds, shepherdesses
**Invoked:** against plague, leprosy; for an end to excessive rain, the healing of kings

‡

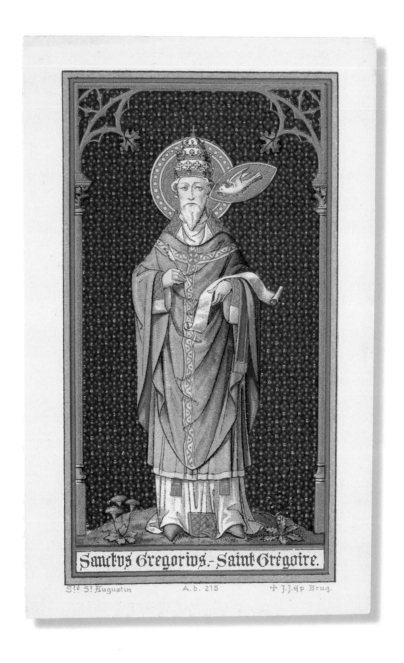

Sanctus Gregorius.-Saint Grégoire.

## Gout / Gregory the Great, 540–604, Feast Day: September 3

A wealthy Roman patrician enjoying a luxurious life, Gregory turned his home into a monastery upon the death of his parents. Against his own wishes, he was named pope. He was responsible for groundbreaking advances in literature and music. Because of the rich diet and wines enjoyed in his youth, he suffered greatly from indigestion and gout.

**Other patronages:** music; popes, scholars, schoolchildren, singers, teachers

**Invoked:** against fires of purgatory, plague

‡

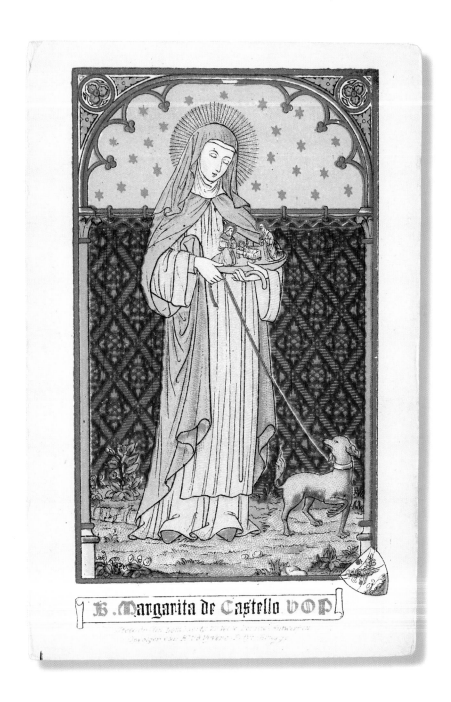

S. Margarita de Castello VOD

## HANDICAPPED PEOPLE / MARGARET OF CASTELLO, 1287–1320, FEAST DAY: APRIL 13

Blind, lame, and a dwarf, Margaret was hidden away by her parents, landed nobles. Since she liked to pray, she was sent to live in a chapel in the woods. When she was twenty, her parents took her to a Dominican convent to seek a miraculous cure. When none came, they deserted her there. She helped out in the daycare center run by the nuns. Beloved by the townspeople, she is credited with curing a crippled girl upon her death.

**Other patronages:** right-to-life movement; unwanted people

‡

ST. THERESIA.

## HEADACHES / TERESA OF ÁVILA, 1515–1582, FEAST DAY: OCTOBER 15

An intellectual and a reformer, Teresa was one of the most popular religious figures of her time and is still widely read today. Because her searing mystical visions would leave her in intense mental anguish, she is invoked against headaches.

**Other patronages:** Spain; lace makers
**Invoked:** against fires of purgatory, heart ailments

‡

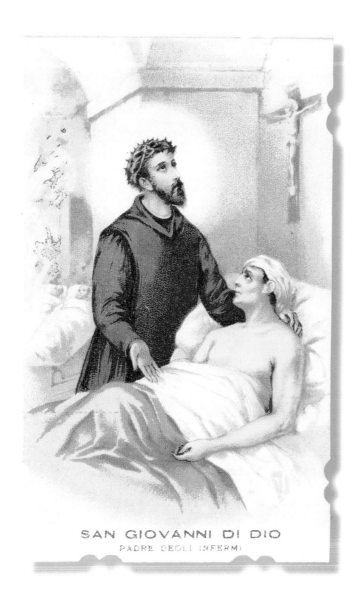

SAN GIOVANNI DI DIO
PADRE DEGLI INFERMI

## HEART AILMENTS / JOHN OF GOD, 1495–1550, FEAST DAY: MARCH 8

A Portuguese mercenary who fought in several wars, sold slaves, and lived hard, John was known to "think with his heart" by acting impulsively. While a bookdealer in Granada, he heard a sermon that changed his life, driving him to madness temporarily. Upon his recovery, he devoted the rest of his life to the sick and destitute. He leaped into a river to save a drowning man and died himself from an overexhausted heart.

**Other patronages:** dying; hospitals; booksellers, nurses, printers
**Invoked:** against alcoholism

‡

S. Bernardin v. Siena.

Thue Alles, was du thust, zur Ehre Gottes u. in vollkommener Liebe.

S. Bernardin v. S.

B.K.  Carl Poellath, Schrobenhausen

## LUNG DISEASES / BERNADINE OF SIENA, 1380–1444, FEAST DAY: MAY 20

An immensely popular Franciscan preacher, Bernadine vowed to preach in every part of Italy. Thoroughly entertaining to common people, he would speak in the open air for four hours at a time. Because he often strained his voice, he suffered from hoarseness, like patients with pulmonary problems. A master communicator, he designed the IHS visual emblem of Christ.

**Other patronages:** advertisers, pugilists, weavers, wool merchants
**Invoked:** against hemorrhages, hoarseness, tuberculosis

☩

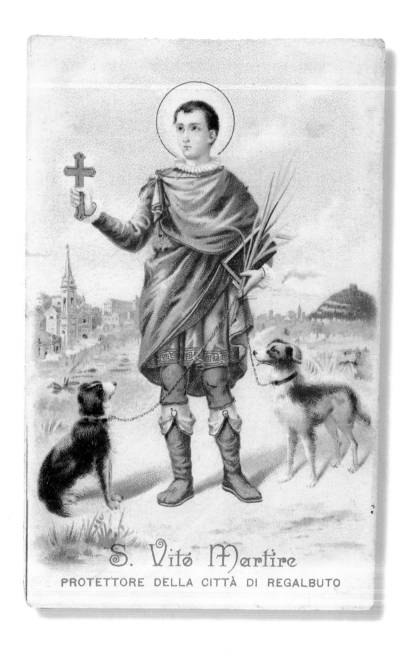

S. Vito Martire
PROTETTORE DELLA CITTÀ DI REGALBUTO

## NEUROLOGICAL DISORDERS / VITUS, D. 303, FEAST DAY: JUNE 15

A Sicilian boy who converted to Christianity at a young age, Vitus exorcized a demon from the son of Emperor Diocletian. While he was imprisoned because of his faith, a band of dancing angels would entertain him. He was martyred by being thrown in a cauldron of boiling pitch. In Germany, his shrine was visited by many people with nerve disorders, and it became customary to dance all night on his feast day.

**Other patronages:** Bohemia, Sicily; hens, roosters; actors, brewers, comedians, coppersmiths, coopers, dancers, pharmacists, tinkers, vintners; epileptics, insane people

**Invoked:** against bedwetting, snakebite, wild-animal attacks

‡

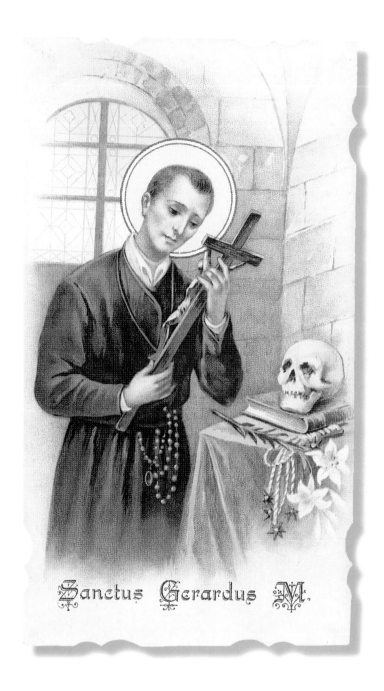

Sanctus Gerardus M.

PREGNANCY / GERARD MAJELLA, 1725–1755, FEAST DAY: OCTOBER 16

A simple-minded lay brother, Gerard was known for working wonders. Once, after he had been visiting friends, their daughter tried to return a handkerchief he had left behind. He refused it, telling her it might be useful to her one day. Years later, she had it brought to her when she was dying in childbirth. She lived to deliver a healthy baby, and the handkerchief is still a popular relic for expectant mothers.

**Other patronages:** lay brothers, mothers
**Invoked:** against infertility

✝

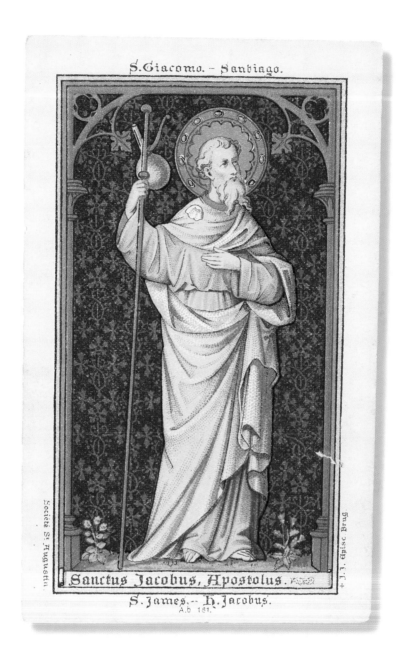

## RHEUMATISM / JAMES THE GREATER, D. A.D. 44, FEAST DAY: JULY 25

A cousin of Jesus and one of the original twelve apostles, James was sent to Spain to spread Christianity. Upon his return to Jerusalem, he was martyred. His remains were put in a boat that washed up on the shores of Galicia. A cathedral dedicated to Saint James was built nearby, and it became the most important pilgrimage site in Europe. Because pilgrims sleep on the floor, they are subject to arthritic and rheumatic pains.

**Other patronages:** Guatemala, Spain; partridges; cavalrymen, hatters, horse traders, shoemakers, pharmacists, pilgrims; hanged people

**Invoked:** for a good apple harvest

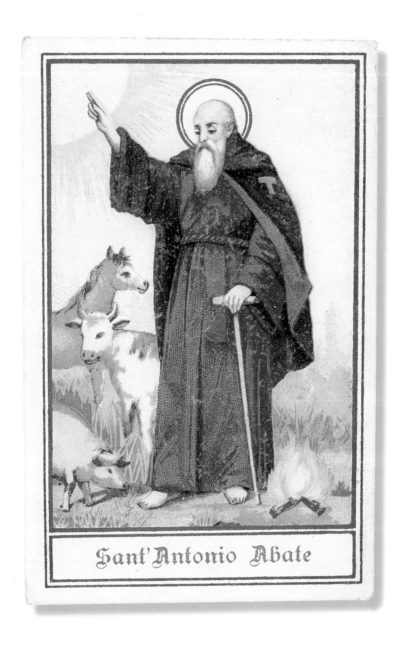

Sant'Antonio Abate

SKIN DISEASES / ANTHONY THE ABBOT, 251–356, FEAST DAY: JANUARY 17

Known as the father of Christian monasticism, Anthony lived a solitary existence in the desert under the motto "pray and work." Constantly tempted by the Devil, he is frequently depicted with his pet pig. In the Middle Ages, pig products were used to calm skin inflammations, and praying to Anthony was said to relieve the pain of shingles and a contagious skin disease known as "St. Anthony's Fire."

**Other patronages:** domestic animals, pigs; bell makers, bell ringers, butchers, brush makers, firefighters, gravediggers, grocers, hermits, swineherds

**Invoked:** against the fires of hell, infections

✝

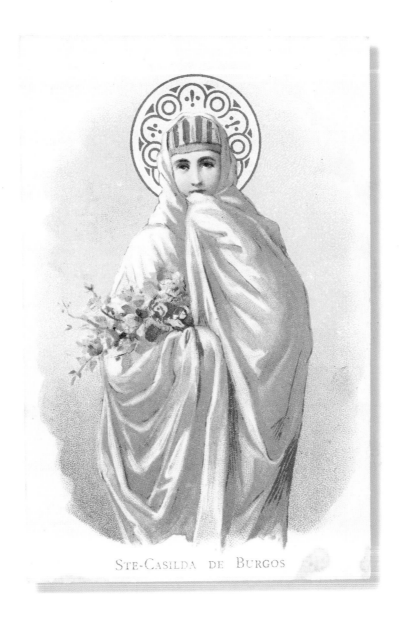

STE-CASILDA DE BURGOS

## STERILITY / CASILDA OF TOLEDO, D. 1050, FEAST DAY: APRIL 9

The Muslim daughter of the Emir of Toledo, Casilda had great compassion for Christian prisoners, frequently sneaking them food. When she fell ill with a uterine hemorrhage, she made a pilgrimage to the sanctuary of Saint Vincent Briviseca in Burgos. She became a Christian after being healed and lived out her life as a hermit near that sanctuary.

**Other patronages:** Burgos (Spain), Toledo (Spain)
**Invoked:** against bad luck, uterine hemorrhage

✝

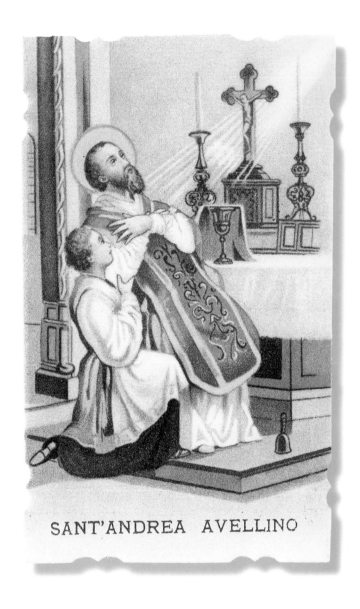

SANT'ANDREA AVELLINO

### STROKE / ANDREW AVELLINO, 1521–1608, FEAST DAY: NOVEMBER 10

An ecclesiastical lawyer, Andrew left the law and devoted himself to the priesthood when he caught himself lying during a trial. He was assigned to close a convent in Naples that had become a brothel. When he succeeded, the local men threatened his life. He traveled through Italy reforming other religious houses. He had an attack of apoplexy and died while saying mass.
**Other patronages:** Naples, Sicily
**Invoked:** against sudden death

✝

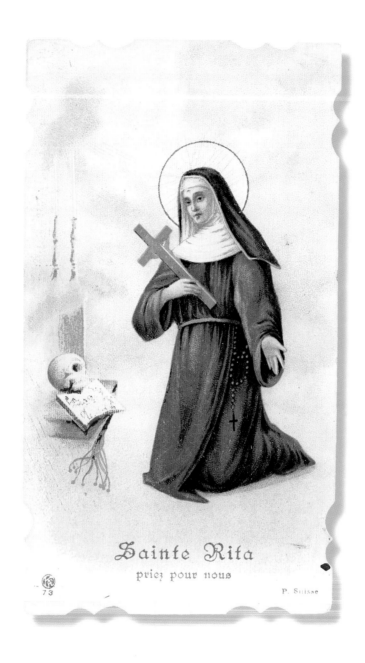

Sainte Rita

priez pour nous

73

P. Suisse

## WOUNDS / RITA OF CASCIA, 1386–1457, FEAST DAY: MAY 22

A widow of an abusive man who was murdered, Rita became an Augustinian nun after her sons died. Known for the efficacy of her prayers, she spent most of her time meditating upon the Passion. A thorn wound appeared on her head after she begged to feel a part of Christ's suffering. This wound plagued her for the rest of her life. Upon her death, roses bloomed off-season and many people in the town reported spontaneous healings.

**Other patronages:** grocers; impossible causes

**Invoked:** against smallpox

‡

# Saints of Nations

**Algeria:** Cyprian of Carthage **Andalusia:** John of Ávila **Argentina:** Francis Solano, Laura Vicuna **Armenia:** Bartholomew the Apostle, Gregory the Illuminator **Australia:** Francis Xavier, Mary Mackillop, Thérèse of Lisieux **Austria:** Colman of Stockerau, Florian, Joseph, Leopold III, Maurice, Severinus of Noricum **Belgium:** Columbanus of Ghent, Joseph **Bolivia:** Francis Solano **Borneo:** Francis Xavier **Brazil:** Anthony of Padua, Peter of Alcantara **Bulgaria:** Cyril, Methodius **Canada:** Anne, George, Isaac Jogues, John de Brébeuf, Joseph **Ceylon:** Lawrence, Thomas the Apostle **Chile:** Francis Solano, James the Greater **China:** Francis Xavier, Joseph **Colombia:** Louis Bertran, Peter Claver **Corsica:** Alexander Sauli, Devota, Julia of Corsica **Croatia:** Joesph **Cyprus:** Barnabas the Apostle **Czech Republic:** Adalbert of Prague, Cyril, John Nepomucene, Ludmila, Methodius, Procopius, Sigismund, Vitus, Wenceslaus **Denmark:** Ansgar, Knud **Dominican Republic:** Dominic de Guzman **East Indies:** Francis Xavier, Thomas the Apostle **Egypt:** Mark the Evangelist **England:** Augustine of Canterbury, Cuthbert, George, Gregory the Great, Michael the Archangel **Ethiopia:** Frumentius of Ethiopia, George **Finland:** Henry of Uppsalla **France:** Anne, Denis, Joan of Arc, Martin of Tours, Remigius, Thérèse of Lisieux **Georgia:** George, Nino **Germany:** Boniface, George, Michael the Archangel, Peter Canisius, Swithbert **Gibraltar:** Bernard of Clairvaux **Greece:** Andrew the Apostle, George, Nicholas of Myra **Guatamala:** James the Greater **Hungary:** Astricus, Gerard Sagredo, Stephen of Hungary **Iceland:** Thorlac Thorhallsson **India:** Francis Xavier, Rose of Lima, Thomas the Apostle **Iran:** Maruthas **Ireland:** Brigid of Ireland, Columba, Kevin, Patrick **Israel:** Michael the Archangel **Italy:** Bernadine of Siena, Catherine of Siena, Francis of Assisi **Japan:** Francis Xavier, Peter Baptist, Paul Miki **Jordan:** John the Baptist **Korea:** Joseph **Lithuania:** Casimir of Poland,

Cunegundes, George, John of Dukla, John of Kanty Luxembourg: Cunegundes, Philip the Apostle, Willibrord Macedonia: Clement of Ohrid Madagascar: Vincent de Paul Malta: George, Paul the Apostle Mexico: Elias del Socorro Nieves, Joseph Monaco: Devota Moravia: Cyril, Methodus, Wenceslaus the Netherlands: Bavo, Plechelm of Guelderland, Willibrord New Zealand: Brigid of Ireland, Francis Xavier Nicaragua: James the Greater Nigeria: Patrick North Africa: Cyprian of Carthage Norway: Olaf II Pakistan: Thomas the Apostle Palestine: George Panama: Louis Bertram Papua New Guinea: Michael the Archangel Paraguay: Francis Solano Peru: Francis Solano, Joseph, Martin de Porres, Rose of Lima, Turibius of Mogroveio Philippines: Rose of Lima Poland: Adalbert of Prague, Andrew Bobola, Casimir of Poland, Cunegundes, Florian, Hyacinth, John of Dukla, John of Kanty, Stanislaus of Cracow Portugal: Anthony of Padua, Francis Borgia, Gabriel the Archangel, George, John de Brito, Vincent of Saragossa Prussia: Adalbert of Prague, Bruno of Quefort, Dorothy of Montau, Judith of Prussia Romania: Nicetas of Remesiana Russia: Andrew the Apostle, Basil the Great, Boris, Nicholas of Myra, Thérèse of Lisieux, Vladimir I of Kiev San Marino: Marinus Scandanavia: Ansgar Scotland: Andrew the Apostle, Columba, Margaret of Scotland, Palladius Serbia: Sava Silesia: Hedwig Spain: James the Greater, John of Ávila, Teresa of Ávila Sri Lanka: Lawrence, Thomas the Apostle Sudan: Josephine Bakhita Sweden: Ansgar, Bridget of Sweden, Eric of Sweden, Gall, Sigfrid Syria: Barbara, Sergius Ukraine: Josaphat Uruguay: James the Lesser, Philip the Apostle Vietnam: Joseph, Thérèse of Lisieux Wales: David of Wales West Indies: Gertrude the Great, Gregory the Great, Rose of Lima Yugoslavia: Cyril, Methodius

After the Pentecost, when the twelve apostles were sent on missions to spread the words of Christ, the known world was divided up into regions for evangelization by his followers. Most of these early preachers suffered martyrdom in the provinces of their ministry and therefore have been named patrons of these countries. Over the centuries, as Christianity spread, missionaries pushed into newly discovered territories, greatly influencing the course of events in these regions. For the most part, these first missionaries, whose work shaped a country's history, are designated national patrons. Patronage can also be derived from the extraordinary leadership of a ruler or from the popularity of a cult figure such as Saint George, who captured the imagination of England—a country he never even heard of in his own lifetime.

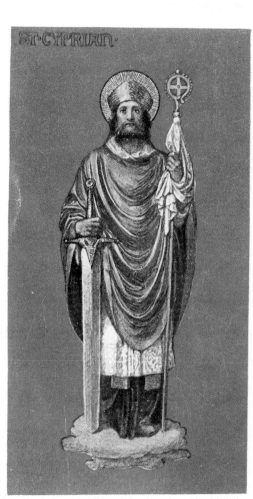

St. Cyprian

Am Hochaltar der Franziskushauskapelle Altötting

Der heilige Cyprian

Bischof von Karthago, grosser Armenfreund und
Schriftsteller; wurde gemartert 258, 16. September.

## ALGERIA / CYPRIAN OF CARTHAGE, 190–258, FEAST DAY: SEPTEMBER 16

Known as "the African Pope," Cyprian did not convert to Christianity until the age of fifty. After living so long as a wealthy dissolute, he began to devote his life to chastity, obedience, and poverty. He was extremely popular throughout northern Africa and was proclaimed bishop one year after becoming a priest. His writings did much to shape the early Church. He was martyred by the Romans in his own villa.

**Other patronages:** North Africa
**Invoked:** against plague

‡

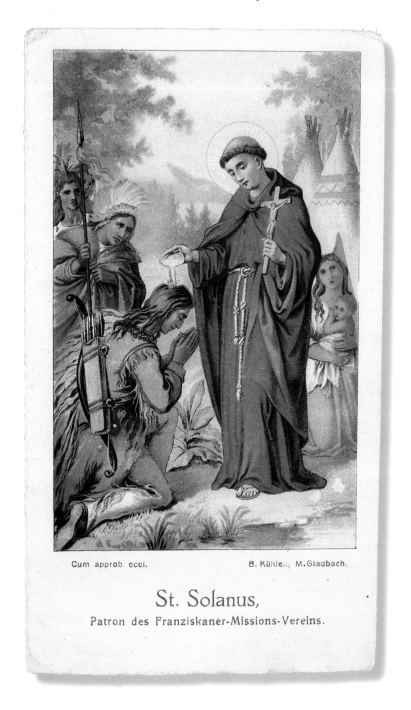

Cum approb. eccl.                    B. Kühle., M.Gladbach.

## St. Solanus,
### Patron des Franziskaner-Missions-Vereins.

ARGENTINA / FRANCIS SOLANO, 1549–1610, FEAST DAY: JULY 14

A missionary from Andalusia in Spain, Francis traveled to South America on a slave ship. The ship ran aground in a storm and was deserted by the captain and crew. Francis stayed with the slaves until their rescue. He was one of the first Europeans to travel in the Argentine rain forest, and he learned the languages of the indigenous people. He worked extensively in Lima, Peru, for the rights of native peoples. He had the gift of second sight and was a great healer.

**Other patronages:** Bolivia, Chile, Paraguay, Peru

✝

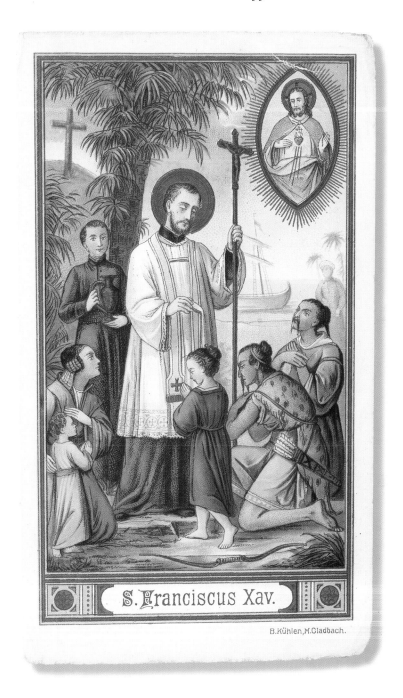

S. Franciscus Xav.

B.Kühlen,M.Gladbach.

## Australia / Francis Xavier, 1506–1552, Feast Day: December 3

A friend of Ignatius Loyola, founder of the Jesuits, Francis became one of the most successful missionaries in history. Dedicated to working in the Far East, he converted over forty thousand people in Goa, India, Malaysia, the Philippines, and the outer islands of Japan. He died before he could reach China. After his death, he often became the patron of territories in newly discovered regions of the world.

**Other patronages:** Borneo, China, India, Japan, Pakistan, Portugal; foreign missions; sailors, tourists
**Invoked:** against hurricanes, plague

✝

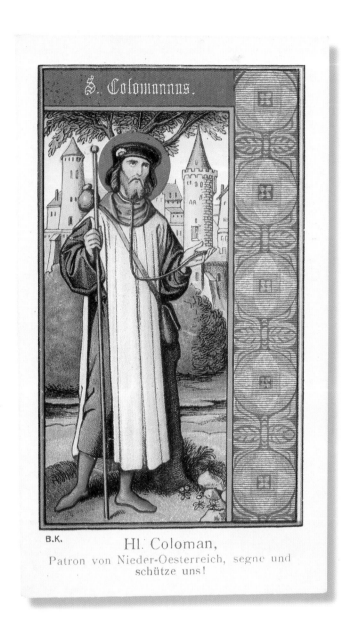

S. Colomannus.

Hl. Coloman,
Patron von Nieder-Oesterreich, segne und
schütze uns!

## AUSTRIA / COLMAN OF STOCKERAU, D. 1012, FEAST DAY: OCTOBER 13

A monk from the British Isles, Colman was making a pilgrimage to the Holy Land when he was stopped in Austria under suspicion of spying for their enemy, Moravia. Unable to speak German, he could not defend himself and was tortured and hanged. His body was left to dangle as a warning, and for eighteen months, it did not decompose and no animal touched it. The Austrians recognized this as a sign of his sanctity and made him their patron.

**Other patronages:** horned cattle, horses; hanged men
**Invoked:** against hanging, plague

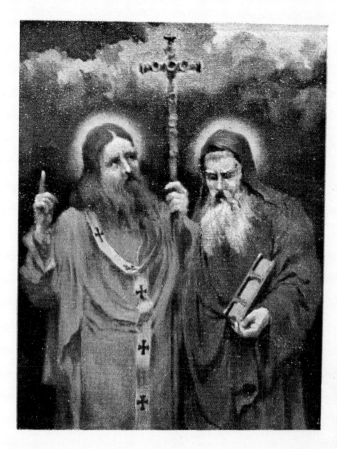

O. Rosenbaum        S cirk. schv.        B B 1006

## SV. CYRIL A METODĚJ

BULGARIA / CYRIL AND METHODIUS, 827–869 / 826–885, FEAST DAY: FEBRUARY 14

Known as "the Apostles to the Slavs," these two brothers gave up the comfortable lives into which they were born to become priests. They were summoned to work in Moravia, where they began to teach in the native language, instead of the traditional Greek or Latin. They are credited with inventing the Cyrillic alphabet and are also considered the fathers of Slavonic literature. After their deaths, their methods of teaching were spread to Bulgaria, Serbia, and Russia.

**Other patronages:** Europe; professors, teachers

✠

Stus Ludovicus Bertrandus

COLOMBIA / LOUIS BERTRAN, 1526–1581, FEAST DAY: OCTOBER 9

Though he was only in Central America for six years, Louis Bertran baptized tens of thousands of people. A Spanish speaker, he had the gift of tongues, which helped the native population understand him. A warrior tribe made a failed attempt to poison him. On his return to Spain, he trained other preachers and campaigned against the cruelty of the Spanish soldiers in the New World.

**Other patronages:** Panama

## CZECH REPUBLIC / WENCESLAUS, 907–929, FEAST DAY: SEPTEMBER 28

Influenced by his Christian grandmother, Ludmila, Wenceslaus inherited the throne of Bohemia (located within the Czech Republic) and opened international relations with other Christian countries. He was so devout that he grew the grapes for the Communion wine and prepared the bread for the Eucharist. After he was murdered by his brother outside the doors of the church, he became a national hero.

**Other patronages:** Bohemia, Prague; brewers; prisoners

‡

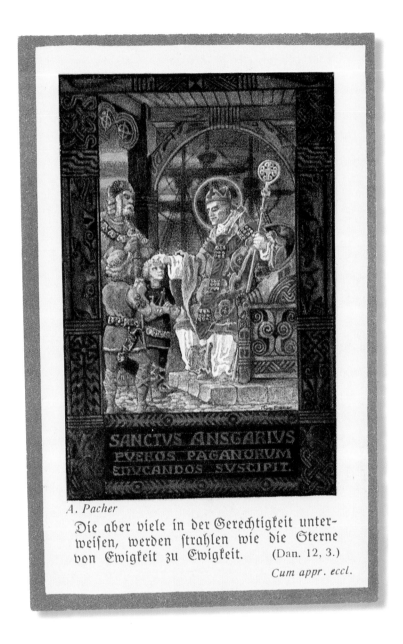

A. Pacher

Die aber viele in der Gerechtigkeit unter-
weisen, werden strahlen wie die Sterne
von Ewigkeit zu Ewigkeit.     (Dan. 12, 3.)

*Cum appr. eccl.*

## DENMARK / ANSGAR, 801–865, FEAST DAY: FEBRUARY 3

Born in northern France, Ansgar earned the title of "Apostle of the North" by accompanying the newly baptized King Harald home to Denmark, where he set up the first Christian missions in Scandinavia. He was invited to Sweden, where he erected the first Christian church in an area extremely hostile to the new faith. As the bishop of Bremen, Ansgar witnessed the destruction of all he had worked for when the Vikings leveled his churches. His visions assured him his work would not be in vain. Two hundred years after his death, missionaries succeeded in evangelizing these northern countries in his name.

**Other patronages:** Germany, Iceland, Sweden

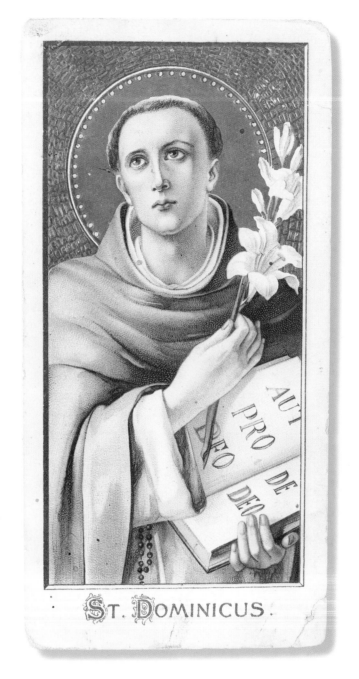

ST. DOMINICUS.

## DOMINICAN REPUBLIC / DOMINIC DE GUZMAN, 1170–1221, FEAST DAY: AUGUST 8

The island nation of Hispaniola was named after this saint in 1508, shortly after its discovery by the Spanish. Dominic founded the traveling Order of Preachers (known as the Dominicans) to combat heresies by preaching from town to town. Before his birth, his grandmother saw him with a star shining from his forehead, shedding light on the world, and his mother had a vision of him as a little dog in her womb who, when born, set the world on fire with a torch he carried in his mouth.

**Other patronages:** Bologna, Caleruega (Spain), Naples, Tolosa (Spain); astronomy; astronomers, preachers, scientists, seamstresses, tailors; falsely accused people

**Invoked:** against drowning

✝

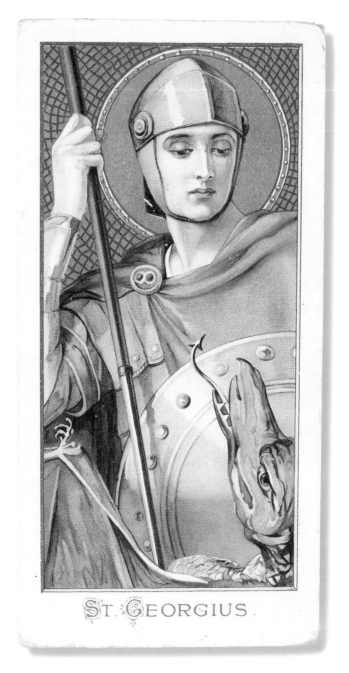

ST. GEORGIUS.

## ENGLAND / GEORGE, D. 304, FEAST DAY: APRIL 23

A soldier from Palestine fighting for the Roman army in Libya, George killed a dragon that was eating two townspeople a day. He then rescued the king's daughter and was given a white banner with a red cross on it, which he used to convert the town. George's cult was brought back to England during the Crusades, when soldiers reported seeing him on horseback. His banner was adapted for soldier's uniforms and official seals in England.

**Other patronages:** Aragon (Spain), Catalonia (Spain), Genoa, Georgia, Germany, Greece, Istanbul, Lithuania, Moscow, the Netherlands, Palestine, Portugal, Venice; horses; the Crusades; equestrians, farmers, scouts

**Invoked:** against herpes, leprosy, snakebite, syphilis

‡

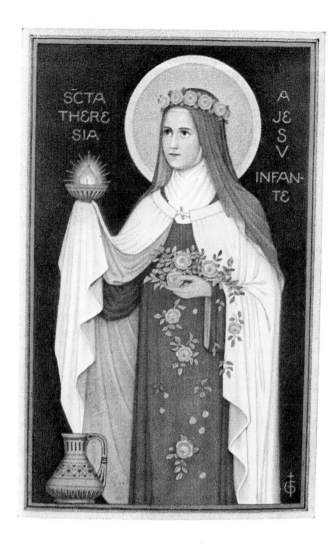

K. BEURON 1056                    MADE IN GERMANY

## FRANCE / THÉRÈSE OF LISIEUX, 1873–1897, FEAST DAY: OCTOBER 1

A French Carmelite nun who desperately wanted to be a missionary to the Far East, Thérèse was stricken with tuberculosis and never left her convent for the remainder of her short life. Her autobiography, *A Story of a Soul*, in which she details her lapse from and return to grace by utilizing "the little way," became a sensational bestseller in France and the rest of the world. She vowed to dedicate herself to love, and today she is one of the most popular saints, especially among the young.

**Other patronages:** AIDS patients, tuberculosis patients; Russia, Vietnam; foreign missions; florists, pilots

**Invoked:** for a loving atmosphere

✠

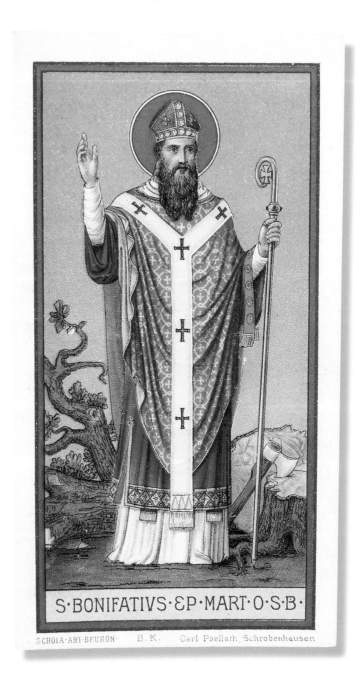

S·BONIFATIVS·EP·MART·O·S·B·

SCHOLA·ART·BEURON·   B.K.   Carl Poellath, Schrobenhausen

## GERMANY / BONIFACE, 680–754, FEAST DAY: JUNE 5

An English monk, his interest in his Saxon roots took him to Germany, where he changed his name to Boniface and successfully evangelized the tribes that lived there. He chopped down the oak tree sacred to Thor, and when the crowds saw there was no retribution paid for this act, they began to follow him. A happy and popular man, he attracted many English priests and nuns to join him. He was murdered in the Netherlands while reading in his tent.

**Other patronages:** World Youth Day; brewers, file cutters, tailors

‡

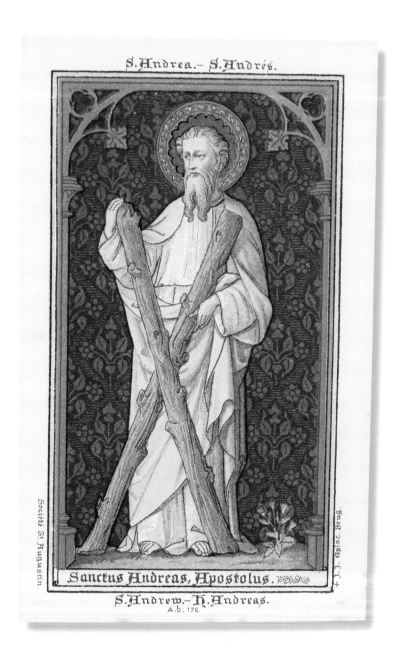

S. Andrea. – S. Andrés.

Sanctus Andreas, Apostolus.

S. Andrew. – H. Andreas.
A.D. 176.

GREECE / ANDREW THE APOSTLE, FIRST CENTURY A.D., FEAST DAY: NOVEMBER 30

One of the original twelve apostles, Andrew was given Scythia, in what is now Russia, for his mission. It is doubtful whether he ever reached it. He was executed in Greece for converting the wife of the governor of Patras. He was tied to an X-shaped cross (known as a saltire cross), from which he preached for two days before dying. In the eleventh century, his remains were taken to Scotland, where his cross is on the national flag.

**Other patronages:** Amalfi (Italy), Burgundy (France), Russia, Scotland; fish dealers, golfers, sailors, singers; spinsters

**Invoked:** by women who wish to be mothers; against sore throat, gout, neck problems

‡

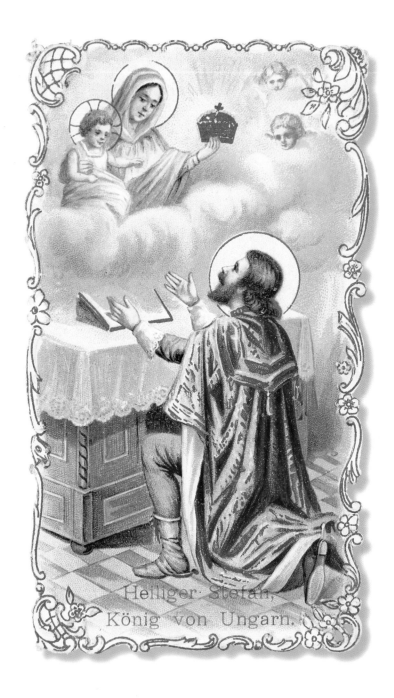

Heiliger Stefan,
König von Ungarn.

## HUNGARY / STEPHEN OF HUNGARY, 975–1038, FEAST DAY: AUGUST 16

The first king of Hungary, Stephen was born into the pagan Magyar tribe and baptized as a young boy in order to make peace with Rome. He took his religion seriously and organized Hungary into one nation, building churches in every town. He outlived all of his children and his later years were filled with sorrow. His incorrupt right hand is one of Hungary's greatest treasures.

**Other patronages:** bricklayers, kings, masons, stonecutters; death of children

✠

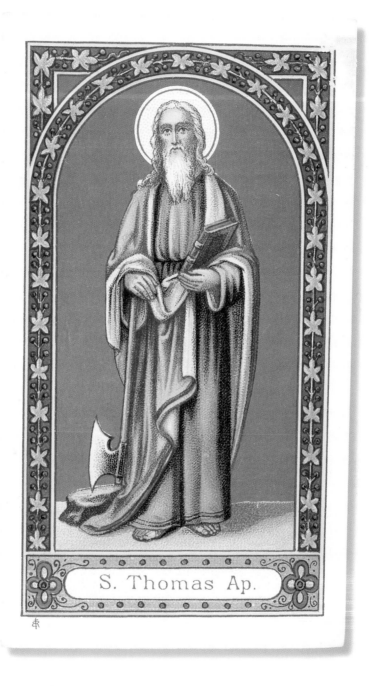

S. Thomas Ap.

INDIA / THOMAS THE APOSTLE, FIRST CENTURY A.D., FEAST DAY: JULY 3

Thomas was the apostle who doubted the resurrection until he felt Christ's wounds. His area of evangelization was India. A king had him design a fabulous palace and gave him a large sum of money to build it. Instead, he gave the money to the poor, saying he was building the king's palace in heaven. He was martyred there by sword.

**Other patronages:** the East Indies, Pakistan, Sri Lanka; architects, builders, construction workers, engineers, geometricians, masons, stonecutters, surveyors, theologians

**Invoked:** against doubt

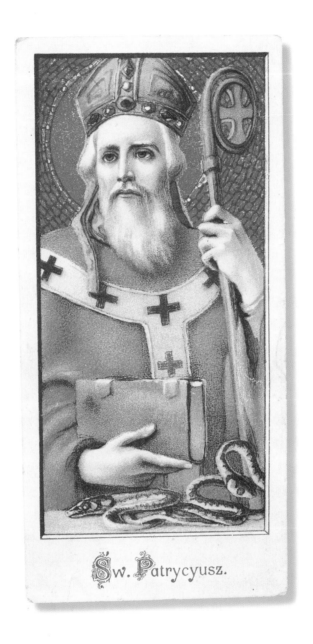

Św. Patrycyusz.

### IRELAND / PATRICK, 390–461, FEAST DAY: MARCH 17

A British subject of Rome, Patrick was kidnapped by pirates and taken to Ireland when he was sixteen. After six years of herding sheep and being exposed to the elements, he managed to escape. He studied to become a missionary to Ireland and on his return devoted himself to evangelizing the tribes there. It was said he had more power over nature than the druidic priests. He rid the island of snakes and could control the weather. He was granted his request to God that the Irish be judged by him when they died. He is a national hero there and his cult has spread all over the world.

**Other patronages:** Nigeria
**Invoked:** against rabies, serpents, the torments of hell

‡

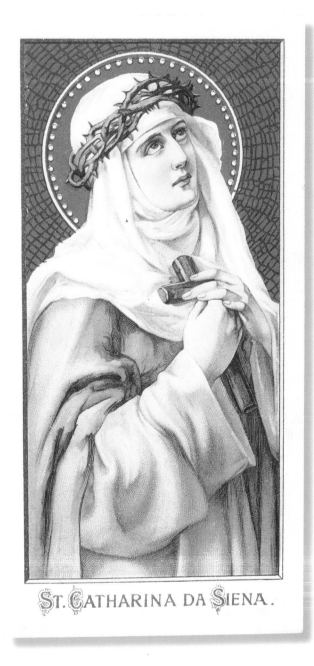

ST. CATHARINA DA SIENA.

ITALY / CATHERINE OF SIENA, 1347–1380, FEAST DAY: APRIL 29

As a young girl, she defied her parents and took up the religious life. A tertiary in the Order of St. Dominic, she tended the incurably ill. Catherine received the stigmata, and she developed a following of young people. Her series of dictated letters are classics of Italian literature. She convinced the Pope to return the Holy See from Avignon, France, to Rome, and this made her the patron of Italy.
**Other patronages:** Europe; fire prevention, nursing services; firefighters, laundresses; sick people
**Invoked:** against burns, miscarriage, temptation

‡

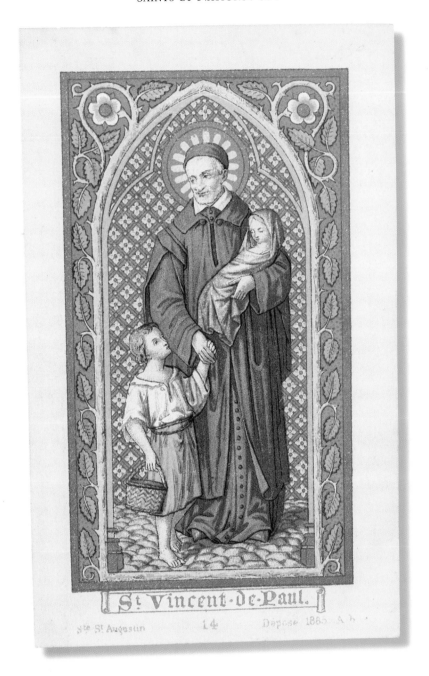

St. Vincent-de-Paul.

## MADAGASCAR / VINCENT DE PAUL, 1581–1660, FEAST DAY: SEPTEMBER 27

A peasant from Gascony, France, Vincent became a priest at the age of twenty. On a voyage from Marseille, he was sold into slavery by Turkish pirates. After converting his owner, he went to Paris, where he devoted himself to the poor, the forgotten, and prisoners. Depending upon divine providence, he developed a welfare system and a network of charities, which he brought to the French countryside, Scotland, Italy, and the territory of Madagascar.

**Other patronages:** Richmond (Virginia); charitable societies; charity workers; abandoned children, orphans, prisoners, slaves

**Invoked:** against leprosy

☩

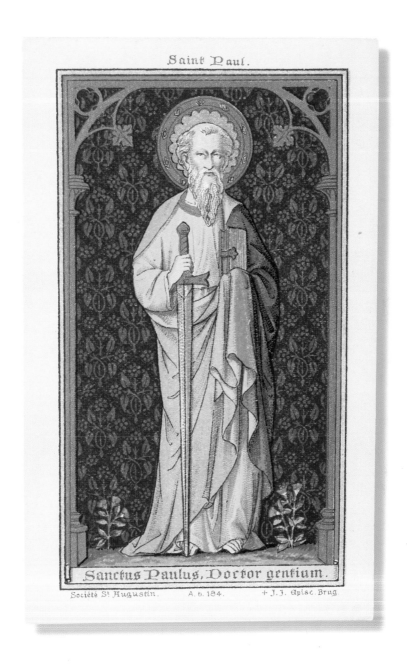

Saint Paul.

Sanctus Paulus, Doctor gentium.

Société St. Augustin.   A. b. 184.   + J. J. Episc. Brug.

## MALTA / PAUL THE APOSTLE, 3–65, FEAST DAY: JUNE 29

Born a Roman citizen in Turkey, Paul was an avid persecutor of the Christians in Jerusalem. Traveling on the road to Damascus, he was thrown from his horse when he had a vision of Christ. After his sudden conversion, he traveled extensively, preaching, writing, and organizing churches, to the dismay of local authorities. He was sent to Rome to be tried for sedition and his ship ran aground at Malta, where he was bitten by a snake and survived. He was later beheaded in Rome.

**Other patronages:** Greece; basket weavers, journalists, polishers, rope makers, swordmakers, tent makers, upholsterers

**Invoked:** against blindness, shipwreck, snakebite

‡

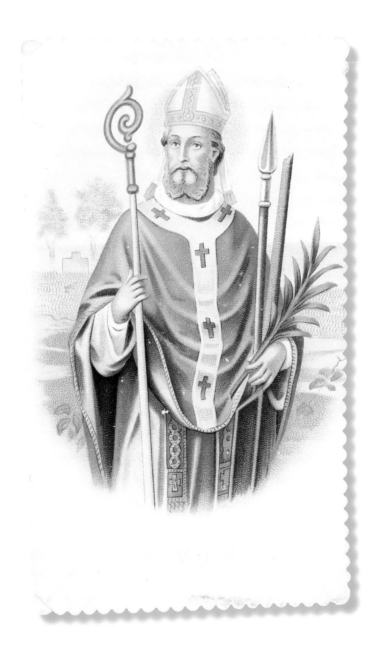

POLAND / ADALBERT OF PRAGUE, 957–997, FEAST DAY: APRIL 23

Born into a noble family in Bohemia, Adalbert took his name from his teacher. By the age of thirty, he was named bishop of Prague. His insistence on distributing his wealth to the poor and his disdain for slavery made him the enemy of the ruling class. He left Prague and lived in Rome until being called back. On his second attempt to live there, he was driven out. He evangelized in Russia and Poland and was murdered in Prussia by pagan priests. His persistence in the face of failure served as an inspiration for future missionaries in that area.

**Other patronages:** Bohemia, Czech Republic, Prussia

‡

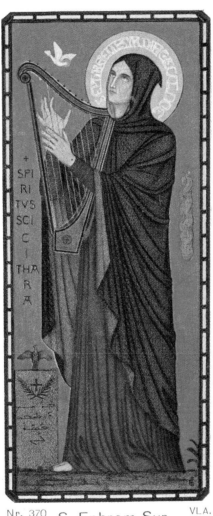

Nr. 370  S. Ephrem Syr.  VLA.

## SYRIA / EPHREM OF SYRIA, 306–373, FEAST DAY: JUNE 9

Born into an early Christian community, Ephrem's great body of writing—his homilies, poems, hymns, and dissertations on Christian philosophy—make him a pillar of both the Syrian and Roman Catholic churches. Driven out of his home in Syria, he found refuge in Edessa, where he lived in a cave and did much of his writing. His work, written in his native language, represents the Church before the influence of Europe.

**Other patronages:** spiritual directors, spiritual leaders

✣

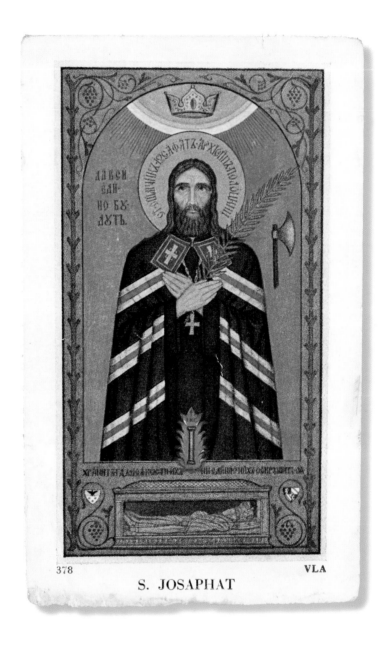

S. JOSAPHAT

### UKRAINE / JOSAPHAT, 1580–1623, FEAST DAY: NOVEMBER 12

The first Eastern Orthodox saint recognized by the Vatican, Josaphat was intent on repairing the Great Schism, which divided the Eastern and Western churches. His virtuous example as a bishop in Belarus inspired many to reunite with the Roman Church. This became a political problem, and when rioting ensued, he traveled to Vitebsk to quell the violence. He was martyred by an angry mob who split his head open with an axe. When his uncorrupt body was recovered from the river, his enemies, ashamed of what they had done, had a complete change of heart on uniting the churches.

‡

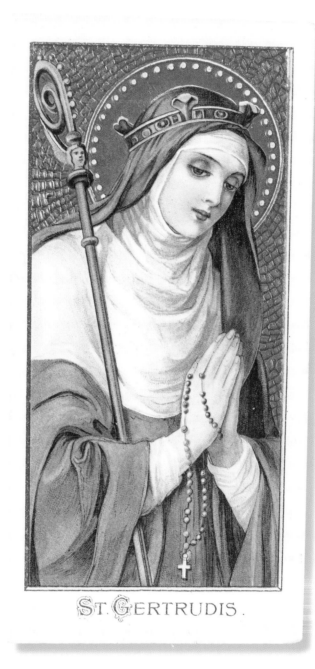

ST. GERTRUDIS.

**WEST INDIES / GERTRUDE THE GREAT, 1256–1302, FEAST DAY: NOVEMBER 16**

Placed in the Cistercian abbey at Helfta in Saxony at the age of five, Gertrude never left the convent. She had a phenomenal intellect and was a student of Saint Mechtild. At the age of twenty-five, she had a vision of Christ that changed the course of her life. She lost all interest in secular studies, concentrating instead on religious literature. Her own mystical writings influenced many future saints, and she was the first to meditate on the sacred heart of Jesus. Her name was entered into the canon of the mass in 1677, and the king of Spain had her named as patron of the West Indies.

**Other patronages:** nuns, travelers

‡

Saints of Nature

animals: Ambrose of Milan, Anthony of Padua, Anthony the Abbot, Beuno, Blaise, Cornelius, Dwynwen, Felix of Nola, Francis of Assisi, Gerlac of Valkenburg, Gratus of Aosta, Guy of Anderlecht, Nicholas of Tolentino, Vitus apple orchards: Charles Borromeo bad weather: Eurosia, Medard bees: Ambrose of Milan, Bernard of Clairvaux, Modomnoc birds: Francis of Assisi, Gall, Milburga blackbirds: Kevin caterpillars: Magnus of Füssen cats: Gertrude of Nivelles cattle: Brigid of Ireland, Castorus, Claudius, Colman of Stockerau, Cornelius, Drogo, Nicostratus, Perpetua, Simpronian cattle disease: Beuno, Erhard of Regensburg, Roch, Sebastian chickens: Brigid of Ireland cold weather: Maurus, Sebaldus cows: Brigid of Ireland, Castorus, Claudius, Colman of Stockerau, Cornelius, Drogo, Nicostratus, Perpetua, Simpronian crops: Agnes, Ansovinus, Magnus of Füssen dogs: Hubert of Liège, Roch, Vitus dog bites: Hubert of Liège, Vitus, Walburga domestic animals: Ambrose of Milan, Anthony of Padua, Anthony the Abbot, Cornelius, Felix of Nola, Gerlac of Valkenburg doves: Columba of Rieti, David of Wales droughts: Catald, Godeberta, Heribert of Cologne, Solange, Swithun, Trophimus of Arles drowning: Adjutor, Florian, Placid, Radegunde, Romanus of Condat earthquakes: Agatha, Emidius, Francis Borgia, Gregory Thaumaturgus explosions: Barbara fire prevention: Agatha, Amabilis, Barbara, Caesarius of Arles, Catherine of Siena, Eustachius, Florian, Francis of Assisi, Francis of Paola, Gratus of Aosta, Jodocus, Lawrence fish: Neot floods: Christopher, Columba, Florian, Gregory Thaumaturgus, John of Nepomucene, Margaret of Hungary frost: Urban of Langres fruitful weather: Agricola of Avignon, Clare of Assisi, Medard geese: Gall, Martin of Tours hail: Barnabas, Christopher, Gratus of Aosta, John

the Baptist, Magnus of Füssen, Paul the Apostle harvests: Anthony of Padua, Florian, Jodocus, Medard, Walburga horses: Anthony of Padua, Colman of Stockerau, Eligius, George, Giles, Hippolytus of Rome, Leonard of Noblac, Martin of Tours, Vincent de Paul insects: Dominic of Silos lambs: John the Baptist lightning: Barbara, Christopher, Gratus of Aosta, Magnus of Füssen, Thomas Aquinas, Victor of Marseilles, Vitus lions: Mark the Apostle livestock protection: Isidore the Farmer mad dogs: Dominic de Silos, Guy of Anderlecht, Hubert of Liège, Otto of Bamberg, Sithney, Walburga moles: Ulric mouse infestation: Gertrude of Nivelles, Martin de Porres, Servatus, Ulric pastures: Wendelin peril at sea: Erasmus, Michael the Archangel pestilence: Aloysius Gonzaga, Anthony the Abbot, Christopher, Cosmas, Damian, Roch pigs: Anthony the Abbot rain: Agricola of Avignon, Gratus of Aosta, Heribert of Cologne, Honoratus of Arles, Isidore the Farmer, Julian of Cuenca, Medard, Odo of Cluny, Scholastica, Solange, Theodore of Sykeon rats: Gertrude of Nivelles, Martin de Porres, Servatus reptiles: Magnus of Füssen sheep: Drogo, George sickness in animals: Beuno, Dwynwen, Nicholas of Tolentino snakebite: Hilary of Poitiers, Patrick, Paul the Apostle, Vitus snakes: Amabilis, Dominic of Sora, Hilary of Poitiers, Magnus of Füssen, Patrick, Paul the Apostle, Pirmin storms: Agrippina, Barbara, Catald, Christopher, Erasmus, Florian, Gratus of Aosta, Henry of Uppsalla, Hermengild, Jodocus, Scholastica, Thomas Aquinas, Urban of Langres, Vitus, Walburga sudden death: Aldegundis, Andrew Avellino, Barbara, Christopher swans: Hugh of Lincoln vineyards: Gratus of Aosta, Medard volcanic eruptions: Agatha, Januarius wasps: Friard whales: Brendan the Navigator whirlpools: Goar wild animals: Amabilis, Blaise, Vitus wolves: Edmund of East Anglia

Even in modern times, no one has control of the natural elements. In agrarian societies, the difference between a fruitful year and total ruination is determined by the weather. Saints sympathetic to those whose livelihood depends on the vagaries of nature and animals either led lives as shepherds and farmers or were named after some flora or fauna. In some cases, after much meditation and prayer, the saint would develop the power to influence nature itself. Saints Francis of Assisi and Martin de Porres are well documented as communicators with animals. Many of these miracle workers are invoked to prevent storms and earthquakes, bring rain to an area suffering from drought, or calm the rage of wild beasts.

✝

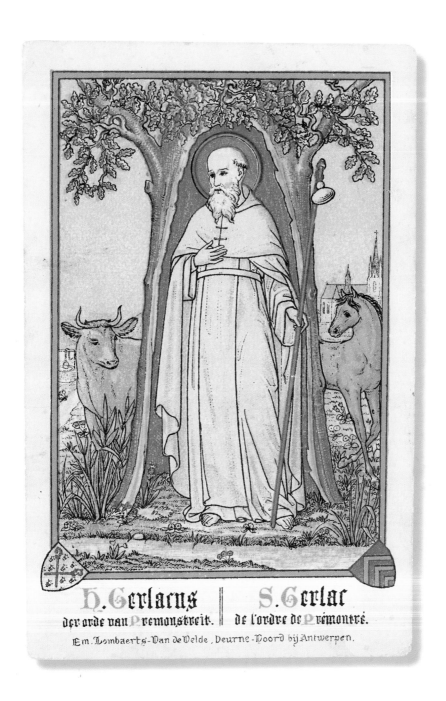

H. Gerlacus
der orde van Premonstreit.

S. Gerlac
de l'ordre de Prémontré.

Em. Lombaerts-Van de Velde, Deurne-Noord bij Antwerpen.

## ANIMALS / GERLAC OF VALKENBURG, 1100–1172, FEAST DAY: JANUARY 5

A Dutch mercenary who led a wild life as a soldier and highwayman, Gerlac was devastated by news of his wife's death. He converted to Christianity and spent the rest of his life doing penance. After caring for the sick in Jerusalem for seven years, he went back to his native Netherlands and returned to nature, living in a hollowed-out tree and communing with the denizens of the forest.

S. Ambrosius.

## BEES / AMBROSE OF MILAN, 340–397, FEAST DAY: DECEMBER 7

It is said that when he was a baby, a swarm of bees went in and out of Ambrose's mouth, feeding him honey. Bees are a sign of divine oratorical gifts. His very name is a derivative of "ambrosia." As bishop of Milan, he was loved by its people for his preaching and for the authoritative way he represented them before the emperors. His literary contributions made him one of the four Doctors of the Western Church.

**Other patronages:** domestic animals, geese; chandlers, orators, stonecutters, wax workers

✝

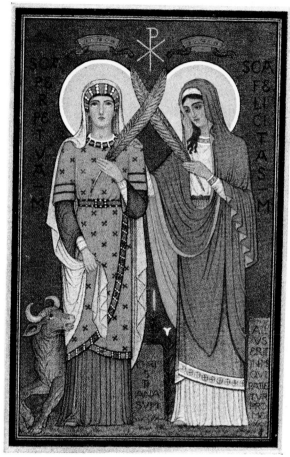

Hle. Perpetua und Felicitas
(6. März)

Nr. 364                                    VLA

## Cows / Perpetua and Felicity, d. 203, Feast Day: March 7

Perpetua was a married noblewoman in Africa and Felicity was a pregnant slave; both were imprisoned together. Perpetua left a detailed journal about their captivity and the persecution of Christians. Perpetua's greatest torment was being separated from her child. Felicity gave birth two days before they were killed in the arena by a herd of wild cattle.

**Other patronages:** mothers

‡

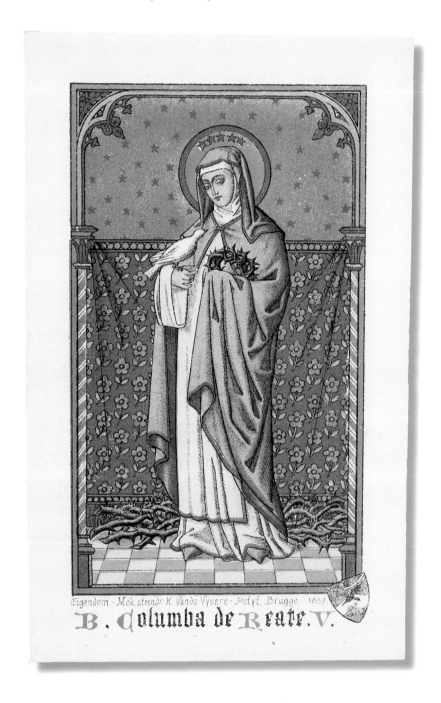

## DOVES / COLUMBA OF RIETI, 1467–1501, FEAST DAY: MAY 20

Named Angelella Guardagnoli by her parents, during her baptism a dove flew down the aisle of the church to her. From then on she was known as Columba ("dove"). A devout girl, she developed the gifts of prophecy and healing, and many sought her out for spiritual advice. Settling in Perugia, Italy, she offered her own health in exchange for that of the city during an epidemic. After falling ill, she herself was healed through the intercession of Saint Catherine of Siena.

**Other patronages:** Perugia
**Invoked:** against sorcery, temptation

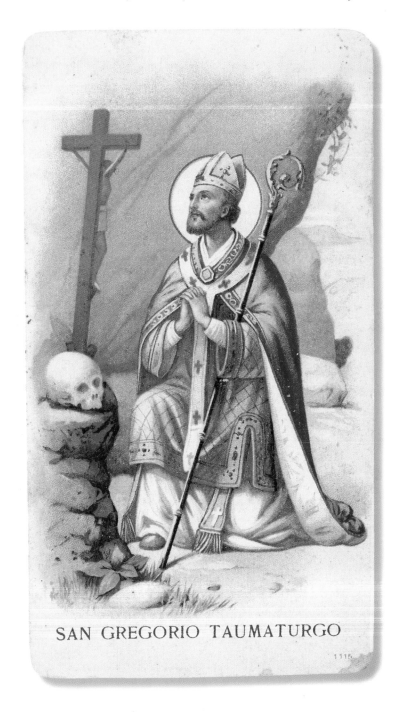

SAN GREGORIO TAUMATURGO

## EARTHQUAKES / GREGORY THAUMATURGUS, 213–270, FEAST DAY: NOVEMBER 17

As a wealthy young law student in Beirut, Gregory converted to Christianity. Upon his return to his native city he was named the bishop of the seventeen Christians who lived there. By the time of his death, all but seventeen pagans had been converted by him. Known for his healing abilities, he could dry up streams and move great boulders with the commands of his word.

**Other patronages:** Armenia; desperate and forgotten causes
**Invoked:** against flooding

‡

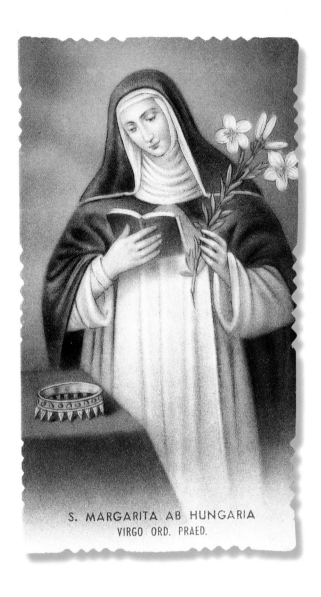

S. MARGARITA AB HUNGARIA
VIRGO ORD. PRAED.

## FLOODS / MARGARET OF HUNGARY, 1242–1271, FEAST DAY: JANUARY 18

A princess whose parents promised her to God in thanks for stopping an enemy invasion, Margaret refused to leave the convent where she was placed. As an act of penance, she refused to wash and tended the hopelessly ill. Her father built her a convent of her own on an isle in the middle of the Danube River. Whenever it was threatened by flooding, she protected it with prayer.

‡

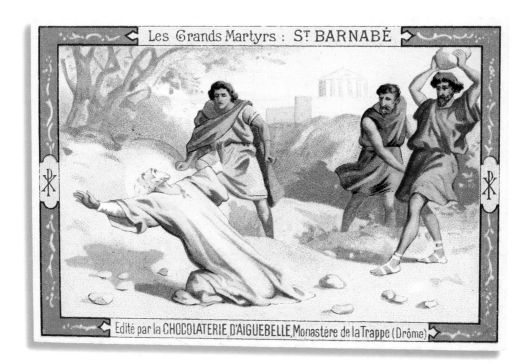

Les Grands Martyrs : Sᵗ BARNABÉ

Edité par la CHOCOLATERIE D'AIGUEBELLE, Monastère de la Trappe (Drôme)

## HAIL / BARNABAS THE APOSTLE, D. 61, FEAST DAY: JUNE 11

Originally from Cyprus, Barnabas was said to have been present at the Pentecost when the Holy Spirit descended on the original followers of Christ. He introduced Saint Paul to the other apostles and became his disciple. He was stoned in Cyprus when he attempted to preach there, and this is why he is invoked against hail. He was burned alive, and when his remains were discovered in 458, the Gospel of Matthew was with them.

**Other patronages:** Antioch, Cyprus
**Invoked:** for peace

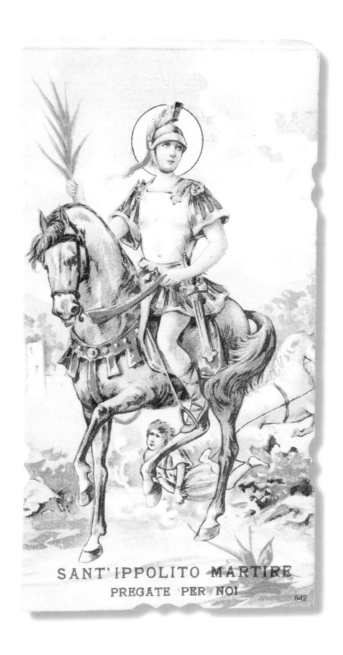

SANT'IPPOLITO MARTIRE

PREGATE PER NOI

642

## HORSES / HIPPOLYTUS OF ROME, D. 236, FEAST DAY: AUGUST 13

His name means "a horse turned loose," and Hippolytus is often confused with Theseus's son of the same name, who was dragged to death by horses. Saint Hippolytus was a Roman Christian so concerned with orthodoxy that he declared himself the antipope. He was exiled to Sardinia and worked in the mines along with Pope Pontian. He reconciled himself with Pontian and they were martyred there together.

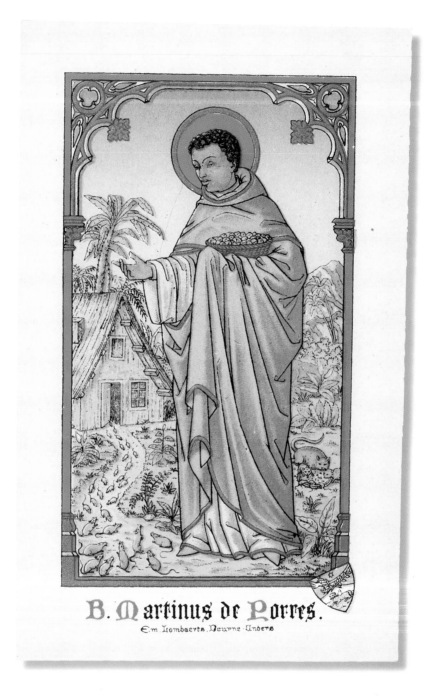

B. Martinus de Porres.
Em Jombaerts Deurne Anders

MOUSE INFESTATION / MARTIN DE PORRES, 1579–1639, FEAST DAY: NOVEMBER 3

Half African, half Spanish, Martin was born in Peru and trained to be a barber. Known for his healing powers and his ability to communicate with all creatures, he was much sought out for advice when he became a Dominican tertiary. He took the most menial jobs out of humility and arranged for the mice to line up and be fed at the end of the day, instead of allowing them to forage throughout the monastery.

**Other patronages:** hairdressers, jurists, public health workers; people of mixed race
**Invoked:** for racial harmony

Die reich werden wollen, fallen in viele Versuchungen und Fallstricke des Teufels.

I. Tim. 6.9.

## PASTURES / WENDELIN, 554–617, FEAST DAY: OCTOBER 21

The pious son of a Scottish king, Wendelin made a pilgrimage to Rome, where he was advised to follow his heart. He toured religious sites in Europe and settled in Germany, where he tended sheep, which enabled him to pray most of the day. Eventually he founded a community of religious hermits that became the Benedictine Abbey of Thole.

**Other patronages:** farmers, shepherds

Carl Pöllath, Schrobenhausen.                754

St. Magnus.

REPTILES / MAGNUS OF FÜSSEN, SEVENTH CENTURY, FEAST DAY: SEPTEMBER 6

An Irish missionary, Magnus settled in Germany. He is credited with banishing snakes from the town of Kempten and driving out a dragon in Füssen before founding a monastery there. A bear showed him where to mine iron ore, and that became the leading industry there.
**Other patronages:** crops
**Invoked:** against caterpillars, hail, lightning, vermin

‡

Pietra offerta per il completamento
della Basilica di S. Gennaro ad Antignano

VOLCANIC ERUPTIONS / JANUARIUS, D. 304, FEAST DAY: SEPTEMBER 19

A bishop martyred in nearby Pozzuoli, Januarius' relics were moved to Naples, where a church was built to house them. A vial of his blood is preserved there. The residents of Naples traditionally invoke the saint when they are threatened by the eruption of nearby Mount Vesuvius. The blood in the vial boils three times a year: on his feast day and on the anniversaries of successful interventions. When it does not boil, there are eruptions from the volcano.

**Other patronages:** Naples; blood banks; nail makers

**Invoked:** against the evil eye

✠

S.EDMUND.K.M.

## WOLVES / EDMUND OF EAST ANGLIA, 841–870, FEAST DAY: NOVEMBER 20

Known as a fair and just ruler, Edmund was a king in eastern England. When the Danes invaded, he was captured and told to turn over his followers. When he refused, he was beaten, shot with arrows, and beheaded. When his followers came to claim his body, they could not find his head. They heard a voice in the woods calling and, following it, found a wolf cradling Edmund's head between its paws.

**Other patronages:** kings; torture victims
**Invoked:** against epidemics, plague

# Saints of Occupations

academics: Brigid of Ireland, Catherine of Alexandria, Nicholas of Myra, Thomas Aquinas accountants: Matthew the Apostle actors: Genesius of Rome, Vitus actresses: Pelagia the Penitent advertisers: Bernadine of Siena altar boys: John Berchmans, Tarcisius ambulance drivers: Michael the Archangel anesthesiologists: Rene Goupil archeologists: Pope Damasus I, Helena, Jerome archers: Christina of Bolsena, Christopher, George, Hubert of Liège, Sebastian architects: Barbara, Bernward, Thomas the Apostle archivists: Catherine of Alexandria, Jerome, Lawrence armorers: Barbara, Dunstan of Canterbury, George, Lawrence, Sebastian arms dealers: Adrian of Nicomedia artillerymen: Barbara art dealers: John the Apostle artists: Fra Angelico, Catherine of Bologna, Luke the Apostle, Michael the Archangel astronauts: Joseph of Cupertino astronomers: Dominic de Guzman athletes: Sebastian authors: Francis de Sales, John the Apostle, Lucy of Syracuse, Paul the Apostle aviators: Joseph of Cupertino, Thérèse of Lisieux bakers: Elizabeth of Hungary, Erhard of Regensburg, Honorius of Amiens, Meingold, Michael the Archangel, Nicholas of Myra, Peter the Apostle bankers: Bernardine of Feltre, Matthew the Apostle, Michael the Archangel barbers: Cosmas, Damian, Louis IX, Martin de Porres bee keepers: Ambrose of Milan, Bernard of Clairvaux, Valentine of Rome beggars: Alexius, Benedict Joseph Labre, Elizabeth of Hungary, Giles, Martin of Tours Bible scholars: Jerome biologists: Augustine of Hippo blacksmiths: Brigid of Ireland, Dunstan of Canterbury, Eligius, Giles, James the Greater, Leonard of Noblac boatmen: Anthony of Padua, Barbara, Brendan the Navigator, Brigid of Ireland, Christopher, Pope Clement I, Cuthbert, Erasmus, Eulalia of Merida, Francis of Paola, Jodocus, John Roche, Julian the Hospitaller, Michael the Archangel, Nicholas of Myra, Nicholas of Tolentino, Peter Gonzales, Phocas the Gardener, Walburga bookbinders: Bartholomew the Apostle, Pope Celestine V, Christopher, Columba, John of God, John the Apostle, Luke the Apostle, Sebastian bookkeepers: Matthew the Apostle booksellers: James Duckett, John of God, John the Apostle, Paul the Apostle, Thomas Aquinas bootblacks: Nicholas of Myra brass workers: Barbara brewers: Amand, Arnulf of Soissons, Augustine of Hippo, Barbara, Boniface, Dorothy of Caesarea, Florian, Lawrence, Luke the Apostle, Medard, Nicholas of Myra, Wenceslaus bricklayers: Stephen of Hungary bridge builders: John Nepomucene, Peter the Apostle bus drivers: Christopher businesswomen: Margaret Clitherow butchers: Adrian of Nicomedia, Anthony the Abbot, Bartholomew the Apostle, George, Lawrence, Luke the Apostle, Peter the Apostle, Thomas Bellacci button makers: Louis IX cab drivers: Christopher, Eligius, Fiacre, Frances of Rome cabinetmakers: Anne, Joseph, Victor of Marseilles carpenters: Anne, Barbara, Eulogius of Cordoba, Joseph, Matthias the Apostle, Thomas the Apostle, Wolfgang carvers: Blaise, Olaf II cavalry: George, Martin of Tours chandlers: Ambrose of Milan, Bernard of Clairvaux, Honorius of Amiens chimney sweeps: Florian choir boys: Dominic Savio, Gregory the Great church cleaners: Theobald Roggeri civil servants: Thomas More clerics: Gabriel of Our Lady of Sorrows, Gabriel the Archangel, Thomas a Becket clockmakers: Eligius, Peter the Apostle clowns: Genesius of Rome, Julian the Hospitaller coachmen: Richard of Chichester coffee house keepers: Drogo coin collectors: Eligius, Stephen the Younger comedians: Genesius of Rome, Lawrence, Vitus composers: Cecilia construction workers: Barbara, Blaise, Louis IX, Thomas the Apostle, Vincent Ferrer cooks: Lawrence, Macarius the Younger, Martha, Pascal Baylon coopers: Abdon, Florian, Leonard of Noblac, Michael the Archangel, Nicholas of Myra, Senen, Urban of Langres coppersmiths: Benedict, Eulogius of Cordoba, Leonard of Noblac, Maurus councilmen: Nicholas of Flüe court clerks: Thomas More courtiers: Gummarus customs officers: Matthew the Apostle cyclists: Catherine of Alexandria dairy workers: Brigid of Ireland dancers: Genesius of Rome, Philemon, Vitus deacons: Lawrence, Marinus, Stephen the Martyr dentists: Apollonia, Foillan dieticians: Martha diplomats: Gabriel the Archangel dyers: Lydia Purpuraria, Maurice ecologists: Francis of Assisi, Kateri Tekakwitha editors: John Bosco, John the Apostle educators: Catherine of Alexandria, Francis de Sales, Gregory the Great, John Baptist de La Salle, Ursula engineers: Benedict, Ferdinand III of Castile, Joseph, Patrick engravers: John the Apostle, Thiemo equestrians: Anne, George, James the Greater, Martin of Tours farmers: Benedict, Bernard of Vienne, Botulph, Eligius, George, Isidore the Farmer, Notburga, Phocas the Gardener, Walstan ferrymen: Julian the Hospitaller firemen: Barbara, Catherine of Siena, Eustachius, Florian, John of God fish mongers: Andrew the Apostle, Magnus fishermen: Andrew the Apostle, Anthony of Padua, Benno, Nicholas of Myra, Peter the Apostle, Zeno of Verona florists: Dorothy of Caesarea, Fiacre, Honorius of Amiens, Rose of Lima, Thérèse of Lisieux forest workers: Gummarus, Hubert of Liège, John Gualbert fruit dealers: Christopher fullers: Anastasius VIII, Christopher, James the Lesser funeral directors: Dismas, Joseph of Arimathea, Sebastian furriers: Hubert of Liège, James the Greater gardeners: Adam, Adelard, Agnes of Rome, Christopher, Dorothy of Caesarea, Fiacre, Gertrude of Nivelles, Phocas the Gardener, Rose of Lima, Sebastian, Tryphon, Urban of Langres, Werenfridus gilders: Clare of Assisi, Eligius glassworkers: Lawrence, Lucy of Syracuse, Luke the Apostle, Mark the Evangelist glovers: Crispian, Crispin, Gummarus, Mary Magdalene goldsmiths: Anastasius the Persian, Bernward, Clare of Assisi, Dunstan of Canterbury, Eligius, Luke the Apostle gravediggers: Anthony the Abbot, Barbara grocers: Leonard of Noblac, Michael the Archangel guardians: Guntramnus, Joseph of Palestine, Mamas gunsmiths: Sebastian hairdressers:

Cosmas, Damian, Louis IX, Martin de Porres, Mary Magdalene healers: Brigid of Ireland hermits: Anthony the Abbot, Giles hospital workers: Camillus of Lellis, John of God, Jude Thaddeus, Vincent de Paul housewives: Anne, Martha, Monica, Zita hunters: Eustachius, Hubert of Liège infantrymen: Maurice innkeepers: Amand, Goar, Julian the Hospitaller, Martha, Martin de Porres, Martin of Tours, Theodatus jewelers: Agatha, Dunstan of Canterbury, Eligius jockeys: Eligius journalists: Francis de Sales, Maximilian Kolbe, Paul the Apostle judges: Ivo of Kermartin, John of Capistrano, Nicholas of Myra knights: Gengulphus, George, James the Greater, Julian the Hospitaller, Michael the Archangel lace makers: Anne, Crispian, Crispin, Elizabeth of Hungary, Francis of Assisi, John Regis, Luke the Apostle, Sebastian, Teresa of Ávila laundresses: Clare of Assisi, Hunna, Lawrence, Martha, Veronica lawyers: Catherine of Alexandria, Genesius of Rome, Ivo of Kermartin, Mark the Evangelist, Raymond of Penyafort, Thomas More leather workers: Bartholomew the Apostle, Crispian, Crispin lectors: Bede the Venerable, Pollio, Sabas librarians: Catherine of Alexandria, Jerome, Lawrence lighthouse keepers: Dunstan of Canterbury, Venerius of Milan linguists: Gotteschalk locksmiths: Dunstan of Canterbury, Eligius, Leonard of Noblac, Peter the Apostle longshoremen: Nicholas of Myra lumberjacks: Gummarus, Hubert of Liège, John Gualbert machinists: Hubert of Liège magistrates: Ferdinand III of Castile, Nicholas of Flüe maids: Adelelmus, Martha, Zita mariners: Anthony of Padua, Barbara, Brendan the Navigator, Brigid of Ireland, Christopher, Pope Clement I, Cuthbert, Erasmus, Eulalia of Merida, Francis of Paola, Jodocus, John Roche, Julian the Hospitaller, Michael the Archangel, Nicholas of Myra, Nicholas of Tolentino, Peter Gonzales, Phocas the Gardener, Walburga masons: Barbara, Blaise, Castorus, Claudius, Pope Clement I, Gregory the Great, Louis IX, Nicostratus, Peter the Apostle, Reinhold, Sebastian, Simpronian, Stephen of Hungary, Stephen the Martyr, Thomas the Apostle mathematicians: Barbara, Hubert of Liège mechanics: Catherine of Alexandria medical technicians: Albert the Great mental health workers: Christina the Astonishing, Dymphna merchants: Amand, Expeditus, Francis of Assisi, Homobonus, Nicholas of Myra messengers: Gabriel the Archangel metal workers: Eligius, Hubert of Liège midwives: Brigid of Ireland, Cosmas, Damian, Dorothy of Caeasara, Drogo, Margaret of Cortona, Peter Verona, Raymond Nonnatus millers: Arnulf of Soissons, Catherine of Alexandria, Christina of Bolsena, Leodegarius, Victor of Marseilles, Winnoc milliners: Barbara, Clement, James the Lesser, Michael the Archangel, Philip the Apostle, Severus of Avranches miners: Anne, Barbara, Eligius, Leonard of Noblac, Piran missionaries: Benedict the Black, Francis Xavier, Leonard of Port Maurice, Peter Claver, Thérèse of Lisieux motorists: Christopher, Elijah the Prophet, Frances of Rome, Sebastian of Aparicio mountaineers: Bernard of Menthon musicians: Benedict Biscop, Cecilia, Dunstan of Canterbury, Genesius of Rome, Gregory the Great, Notkar Balbulus, Paul the Apostle needleworkers: Clare of Assisi, Frances of Assisi, Louis IX, Petca Parasceva, Rose of Lima net makers: Peter the Apostle notaries: Genesius of Arles, Ivo of Kermartin, Luke the Apostle, Mark the Evangelist nurses: Agatha, Alexius, Camillus of Lellis, Catherine of Alexandria, Catherine of Siena, John of God, Margaret of Antioch, Raphael the Archangel obstetricians: Raymond Nonnatus orators: John Chrysostom, Justin Martyr painters: Benedict Biscop, Bernward, Catherine of Bologna, John the Apostle, Luke the Apostle pastry chefs: Honorius of Amiens, Macarius the Younger, Philip the Apostle pawnbrokers: Bernardine of Feltre, Nicholas of Myra perfumers: Mary Magdalene, Nicholas of Myra pharmacists: Cosmas, Damian, Gemma Galgani, James the Greater, James the Lesser, Mary Magdalene, Nicholas of Myra, Raphael the Archangel philosophers: Albert the Great, Catherine of Alexandria, Justin Martyr, Thomas Aquinas physicians: Cosmas, Damian, Luke the Apostle, Panteleon, Raphael the Archangel pilgrims: Alexius, Benedict Joseph Labre, Faith, Gertrude of Nivelles, James the Greater, Julian the Hospitaller, Nicholas of Myra, Pope Pius X plasterers: Bartholomew the Apostle plumbers: Vincent Ferrer poets: Brigid of Ireland, Cecilia, Columba, David police officers: Michael the Archangel, Sebastian politicians: Thomas More porters: Christopher, Leonard of Noblac, Theobald Roggeri postal employees: Gabriel the Archangel potters: Catherine of Alexandria, Goar, Justa, Radegunde, Sebastian, Spyridon preachers: Catherine of Alexandria, John Chrysostom priests: John Mary Vianney, Philomena printers: Augustine of Hippo, Genesius of Rome, John of God, John the Apostle, John the Baptist prisoners: Adelaide, Barbara, Beatrice a Silva Meneses, Charles of Blois, Daniel of Padua, Dismas, Dominic of Silos, Faith, Ferdinand III of Castile, Jacinta Marto, Joan of Arc, Joseph Cafasso, Leonard of Noblac, Louis IX, Mark the Evangelist, Maximilian Kolbe, Medard, Nicholas of Myra, Vincent de Paul, Walter of Pontnoise prisoners of war: Leonard of Noblac, Walter of Pontnoise prison guards: Adrian of Nicomedia, Hippolytus of Rome psychiatrists: Christina the Astonishing, Dymphna scientists: Albert the Great, Dominic de Guzman skaters: Lidwina of Schiedam social workers: John Regis, Louise de Marillac stonecutters: Barbara, Blaise, Castorus, Claudius, Pope Clement I, Gregory the Great, Louis IX, Nicostratus, Peter the Apostle, Reinhold, Sebastian, Simpronian, Stephen of Hungary, Stephen the Martyr, Thomas the Apostle teachers: Catherine of Alexandria, Francis de Sales, Gregory the Great, John Baptist de la Salle, Ursula television workers: Clare of Assisi, Gabriel the Archangel,

Saints come from every walk of life and every line of work known to man. For this reason, the list of occupations and their patron saints is especially extensive. While many saints are associated with a vocation because they practiced that particular profession in their own lifetime, others derive their patronage from more ambiguous circumstances. Because he was born by cesarean section, Saint Raymond Nonnatus is the patron of obstetricians. Saint Mary Magdalene used her hair to dry the washed feet of Christ, so hairdressers claim her as their patron. Traditional iconography can also help decide a patronage. Since Saint Catherine of Alexandria is always depicted with the wheel she was tortured on, all professionals using wheels, such as cyclists, are put under her patronage.

✝

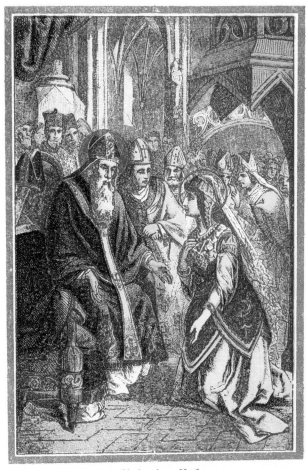

Die hl. Pelagia, Büßerin.

## ACTRESSES / PELAGIA THE PENITENT, DATES UNKNOWN, FEAST DAY: OCTOBER 8

A glamorous and popular actress and dancer in Antioch, Pelagia was known for her pearl jewelry and had the nickname "Margaret," which means "pearl." When she overheard the bishop of Edessa cite her as a lesson because "she takes more trouble over her beauty and dancing than we do about our souls and flocks," she converted. She moved to Jerusalem, disguised as a male monk, and lived for the rest of her life as a hermit in a cave on the Mount of Olives.

‡

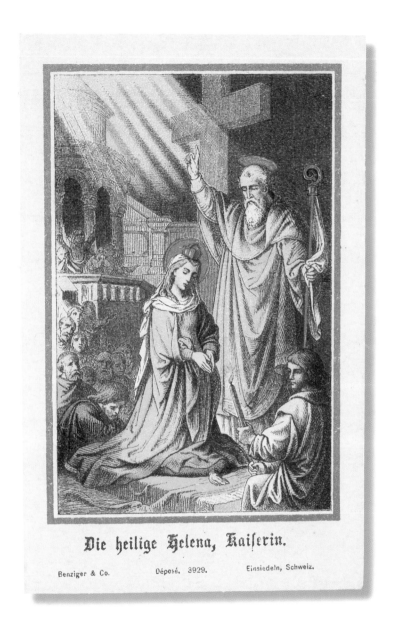

Die heilige Helena, Kaiserin.

Benziger & Co.          Déposé. 3929.          Einsiedeln, Schweiz.

## ARCHEOLOGISTS / HELENA, 250–330, FEAST DAY: AUGUST 18

Married to the coregent of the Western Roman Empire, Helena was divorced by him when he became emperor. Upon his death and the ascension of her son Constantine to the throne, she was installed in court and treated as royalty. A devout Christian, she influenced her son to legalize Christianity. At the age of eighty she traveled to the Holy Land, paying for a successful expedition to uncover the True Cross.

**Other patronages:** Madrid, Paris; dyers, empresses, nail makers; converts, difficult marriages, divorced people

**Invoked:** against demons; to find lost objects

✝

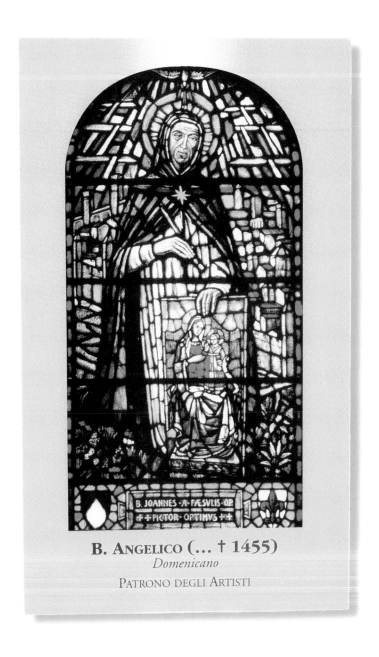

**B. ANGELICO (... † 1455)**
*Domenicano*
PATRONO DEGLI ARTISTI

## ARTISTS / BLESSED FRA ANGELICO, 1387–1455, FEAST DAY: FEBRUARY 18

Born Guido di Pietro in Tuscany, Italy, Fra Angelico became a Dominican monk in Florence. Believing that one must be Christlike to visually depict Christ, he lived a truly Christian life, living humbly and nursing the sick. He meditated and prayed before beginning his paintings, which are considered among the greatest works in art history. He earned the title "Blessed Brother Angel" because of the beauty of his work and the beauty of his soul.

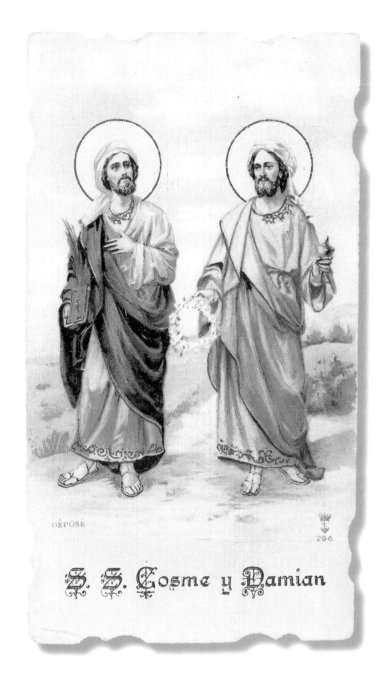

## BARBERS / COSMAS AND DAMIAN, D. 303, FEAST DAY: SEPTEMBER 26

Twin brothers in Syria who were both holy healers, Cosmas and Damian were martyred and buried together. Devout Christians, they never accepted money for their medical treatments of people and animals. They are patrons of barbers because, in ancient times, barbers performed surgery. In Florence during the Renaissance, the Medici family adopted them as patrons and named their children after them.

**Other patronages:** Florence, Prague; hospitals; candy makers, chemical workers, dentists, eye doctors, druggists, midwives, surgeons

**Invoked:** against bladder disease, gangrene, glandular inflammation, indigestion, kidney disease

S. Augustínus

2085        CASM

## BIOLOGISTS / AUGUSTINE OF HIPPO, 354–430, FEAST DAY: AUGUST 28

Born in Africa, Augustine was a brilliant and ambitious professor of rhetoric who moved to Italy. After a dissolute youth, he became a follower of Manichaeism and then Neoplatonism. He was converted to Christianity by his mother, Monica, and Ambrose, bishop of Milan. His writing is considered a cornerstone of Western civilization. He argued against literal readings of the Bible, insisting that the six-day time frame for the creation of the world was meant as a poetic explanation.

**Other patronages:** St. Augustine (Florida); Antonians, Augustinians, Servites, Premonstratensians; brewers, printers, theologians

**Invoked:** against grasshoppers, harmful animals, sore eyes

✢

S. STEPHANUS.

**BRICKLAYERS / STEPHEN THE MARTYR, FIRST CENTURY A.D., FEAST DAY: DECEMBER 26**

One of the seventy-two disciples present at the Pentecost, Stephen was said to be a strong speaker trusted by the original apostles. He was convicted of blasphemy and stoned to death, becoming the first martyr for the faith. He is the patron of anyone who works with stones or who has illnesses relating to stones.

**Other patronages:** casket makers, coachmen, grooms, stonemasons; horses
**Invoked:** against headaches, kidney stones, ringworm

‡

## BUILDERS / VINCENT FERRER, 1350–1419, FEAST DAY: APRIL 5

A Dominican priest from Valencia, Spain, Vincent Ferrer was a healer and a highly charismatic preacher who generated crowds in the tens of thousands. Demoralized by the Great Schism in the Church, he dreamed that Saints Francis and Dominic implored him to go on apostolic missions. He traveled through Spain, France, Italy, Germany, Belgium, England, Scotland, and Ireland. He is known as patron of builders for his work in strengthening and building up the Church.

**Other patronages:** fields, vineyards; innkeepers, lead casters, pavement workers, plumbers, roofers, straw-hat makers, tile makers

**Invoked:** against epilepsy, headaches, drought, earthquakes, lightning strikes

✠

S.HILDA.V.A.

## BUISNESSWOMEN / HILDA, 614–680, FEAST DAY: NOVEMBER 17

The daughter of English nobility, Hilda was an abbess. She founded the influential Abbey of Whitby, a double monastery that educated both men and women. Her order was devoted to the arts and sciences, and she was the patroness of the first English poet, Caedmon. Her management skills and wisdom were legendary; many important rulers and kings asked for her advice and guidance.

‡

St Fiacre

## Cab Drivers / Fiacre, d. 670, Feast Day: August 30

An Irish monk skilled in the arts of healing and herbology, Fiacre fled to Brittany to avoid the throngs of people asking him for cures and advice. He created a hermitage near a spring and it was said that by walking and poking the earth with a stick, he would get a full-grown garden to appear. In seventeenth-century Paris, the Hotel Fiacre rented out carriages that were referred to as "fiacres" by the general public. Cabs in Paris are stilled called by this name.

**Other patronages:** box makers, florists, gardeners, hosiers, tile makers
**Invoked:** against barrenness, fistulas, hemorrhoids, venereal diseases

ST. CATHARINA

CYCLISTS / CATHERINE OF ALEXANDRIA, 287–305, FEAST DAY: NOVEMBER 25

An Egyptian noblewoman, Catherine complained to the emperor about the persecution of the Christians in such a way that she converted his wife and the fifty philosophers who came to argue against her. When all except Catherine were executed, the emperor demanded to marry her. Because she refused, he ordered her to be broken on a spiked wheel, which crumbled to pieces at her touch. She was then beheaded. Because of the wheel, many careers that use wheels were put under her patronage.

**Other patronages:** University of Paris; knife grinders, librarians, mechanics, millers, nurses, philosophers, potters, spinners, students, wheelwrights; dying people, unmarried girls

**Invoked:** to find a husband; against diseases of the tongue

S. Brigida.

B. K.          Carl Poellath, Schrobenhausen

**DAIRY WORKERS / BRIGID OF IRELAND, 453–523, FEAST DAY: FEBRUARY 1**

The daughter of a pagan king and a Christian slave, Brigid helped her mother run her owner's dairy with great success, despite the fact that she gave away more than they sold. After refusing to marry, Brigid entered into religious service and started the great Monastery of Kildare for men and women, which had a world-famous art school. She traveled extensively, founding religious houses throughout Ireland, and is buried with Saints Patrick and Columba.

**Other patronages:** Ireland, New Zealand; nuns, poultry workers, sailors, scholars, travelers; children with unmarried parents, fugitives, newborns

**Invoked:** against fire

Sainte Apolline, priez pour nous

Lith. L. Delvigne-Degallaix, Tournai

### DENTISTS / APOLLONIA, D. 249, FEAST DAY: FEBRUARY 9

During festivities celebrating the Roman occupation of Egypt, a violent mob began attacking Christians. Apollonia, a revered deaconess, was repeatedly hit in the face until her teeth were broken. Confronted with a raging bonfire if she did not denounce her faith, she voluntarily threw herself into the flames. Another version of this story says that she was tortured by having her teeth pulled with pincers before being burned.

**Invoked:** against toothache

© K.Beuron 1216                    Germany

**DOORMEN / CONRAD OF PARZHAM, 1818–1894, FEAST DAY: APRIL 21**

A farmer from Bavaria, Conrad did not become a Capuchin monk until he was in his early thirties. For the next forty years, he was the porter for the shrine of Our Lady of Altotting. He received thousands of pilgrims with charity and kindness, devoting much of his time to teaching local children. It is said he had the gift of prophecy and the ability to read hearts.
**Other patronages:** Capuchin-Franciscan Province of Mid-America

✠

St François le Séraphique.

Ste St Augustin    10    Deposé 1885 A ♭

## ECOLOGY / FRANCIS OF ASSISI, 1181–1226, FEAST DAY: OCTOBER 4

Perhaps the best-loved saint in the world, Francis was a frivolous, wealthy young man who went off to war and was taken prisoner. On his return to his family, he had a complete change of heart, renouncing the material world in favor of nature and simplicity. He founded the Franciscan religious order devoted to love of God and all his creatures. A mystic, he could communicate with animals and was the first saint to receive the stigmata.

**Other patronages:** Italy, Assisi, San Francisco, Santa Fe; animals; animal welfare societies, zoos; lace workers, merchants, needle workers, tapestry workers

**Invoked:** against dying alone, fire

✝

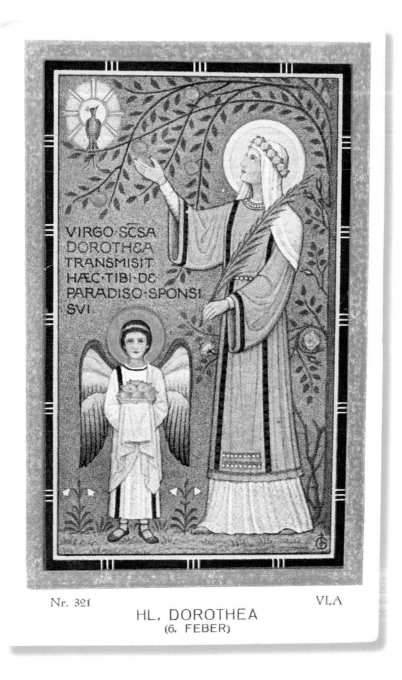

Nr. 321                                                    VLA

HL. DOROTHEA
(6. FEBER)

**FLORISTS / DOROTHY OF CAESAREA, d. 311, FEAST DAY: FEBRUARY 6**

Her name means "gift of God." Dorothy was a young Christian girl living in what is now Turkey. As she was being led away to her martyrdom, a lawyer in the jeering crowd mocked her by asking her to send him some flowers and fruits from the heavenly garden to which she was going. After her death, a child came by his house with Dorothy's veil. Wrapped in it were three apples and three roses; this was in the middle of winter. The lawyer immediately converted and suffered the same fate as Dorothy.

**Other patronages:** brewers, gardeners, midwives; brides, newlyweds

‡

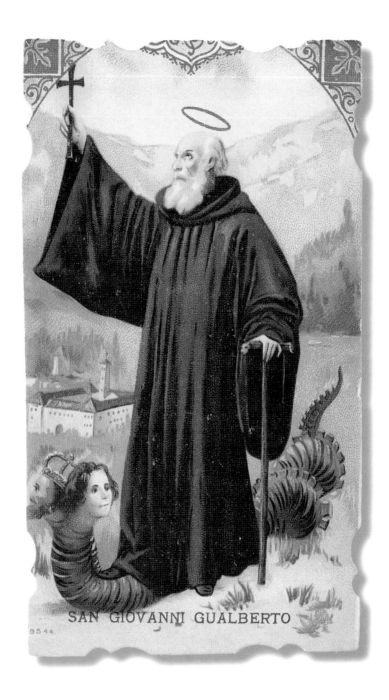

SAN GIOVANNI GUALBERTO

## FOREST WORKERS / JOHN GUALBERT, 985–1073, FEAST DAY: JULY 12

A wealthy soldier from Florence, Italy, John was dedicated to avenging his brother's murder. When he found the man, who fell to his knees begging Christ to accept him, John could not kill him. He underwent a total conversion, eventually founding his own monastery dedicated to wiping out the corruption in the Church. His monks built everything by hand and transformed the wild and barren land into a lush park by planting numerous trees.

**Other patronages:** parks; park keepers

St. Maria Magdalena.

## HAIRDRESSERS / MARY MAGDALENE, FIRST CENTURY A.D., FEAST DAY: JULY 22

One of the first disciples of Christ, Mary Magdalene was a rich and worldly woman who washed Christ's feet and dried them with her long, beautiful hair. She was at the foot of the cross when he was crucified, and she was the first person to see him alive when he rose from the dead. After his Ascension, she is said to have traveled to France and lived the rest of her life as a hermit.
**Other patronages:** carders, gardeners, glovers, perfumers, prostitutes; penitents, prisoners
**Invoked:** against fevers, lust

☩

Sancta·Elisabeth·regina·o·p·n

HOSPITAL WORKERS / ELIZABETH OF HUNGARY, 1207–1231, FEAST DAY: NOVEMBER 17

Daughter of the king of Hungary, Elizabeth had a happy marriage to the prince of Thuringia. Her in-laws were at odds with her interest in caring for the poor and sick. When her husband died on his way to the Crusades, she and her children were turned out by his family. She became a Franciscan tertiary, donating whatever money she had left to building a hospital for the abandoned sick.

**Other patronages:** Germany; charitable associations, Franciscans, hospitals, Knights of the Teutonic Order, Sisters of Charity; bakers; beggars, orphans, unjustly persecuted people, widows

**Invoked:** against in-law problems, plague, ringworm, toothache

✝

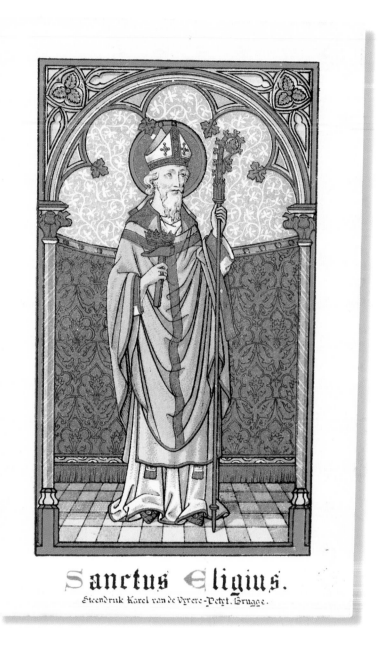

**Sanctus Eligius.**

Steendruk Karel van de Vyvere-Petyt. Brugge.

## JEWELERS / ELIGIUS, 588–660, FEAST DAY: DECEMBER 1

An extraordinary artisan from Limoges, France, Eligius was appointed master of the Mint of France. A devout Christian, he was known for his honesty in working with precious metals and for the beautiful chalices and reliquaries he created. In his mid-fifties, Eligius resigned his official post and became a priest, founding convents and monasteries with his personal fortune. He is the patron of all who work with hammers.

**Other patronages:** horses; blacksmiths, boilermakers, cab drivers, coin collectors, farmers, farriers, garage workers, jockeys, knife makers, miners, minters, veterinarians

**Invoked:** against sickness in horses

✢

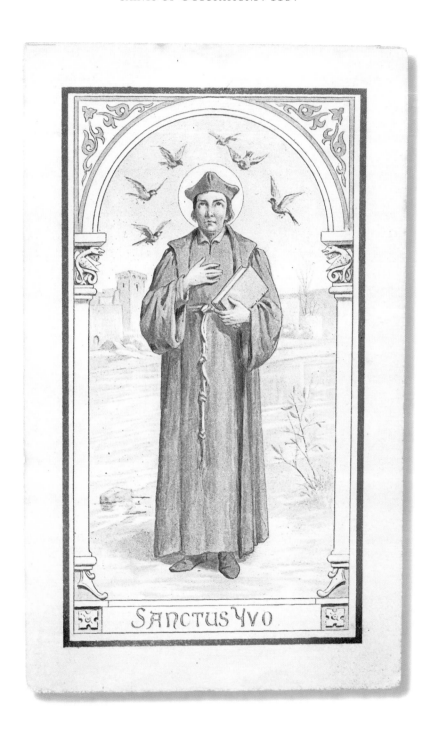

SANCTUS YVO

## JUDGES / IVO OF KERMARTIN, 1253–1303, FEAST DAY: MAY 19

A lawyer from Brittany, Ivo joined the Franciscan tertiaries and became a legal representative for the poor. Appointed to higher legal offices, he was known as an extremely honest and fair judge, especially interested in the fate of orphans. After he was ordained a priest, he gave free legal advice to his parishioners.

**Other patronages:** Brittany; lawyers, notaries; orphans

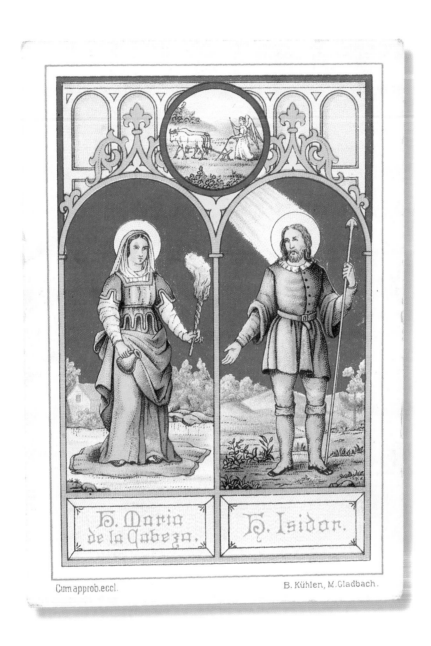

**LABORERS / ISIDORE THE FARMER, 1070–1130, FEAST DAY: MAY 15**

A field hand who spent his entire life working on the same farm outside of Madrid, Isidore and his wife were simple and devout people. When their young son died, they attributed it to God's will that they have no children, and lived chastely thereafter. They spent so much time praying that their employer suspected them of shirking their duties. When he paid them a surprise visit, he found angels plowing the fields while Isidore prayed.

**Other patronages:** Madrid; livestock; rural communities; farmers, ranch hands; death of children;
**Invoked:** for rain

✝

SANT'ANNA

DÉPOSE

### LACEMAKERS / ANNE, FIRST CENTURY B.C., FEAST DAY: JULY 26

Mother of the Virgin Mary and grandmother to Christ, Anne was responsible for teaching Mary about both the spiritual and material worlds. Because she was a housewife, she has many patronages related to the home. She is especially revered in France because, according to legend, she was originally a princess from Brittany who immigrated to Judea and returned home to die.

**Other patronages:** Brittany, Canada, Detroit, France, Quebec; broom makers, cabinetmakers, carpenters, equestrians, glovers, housewives, junk dealers, miners, seamstresses; childless people, grandmothers, pregnant women

**Invoked:** against difficult births, infertility, poverty, thunderstorms

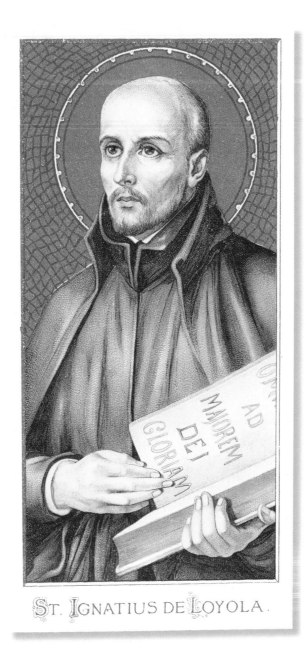

ST. IGNATIUS DE LOYOLA.

## MILITARY / IGNATIUS OF LOYOLA, 1491–1556, FEAST DAY: JULY 31

A son of Spanish nobles and a dedicated soldier, Ignatius' military career ended when he was hit by a cannonball. While recuperating, he read the lives of saints and decided to become a soldier for Christ. After a year in contemplation, he developed his program of "spiritual exercises" that are the basis of today's twelve-step programs. Eventually he founded the Society of Jesus, now called the Jesuits. As an order, they educate over 200,000 students per year in schools and universities all over the world.

**Other patronages:** Basque Country (Spain); religious retreats, spiritual exercises

## MINERS / RUPERT, 660–718, FEAST DAY: MARCH 27

A missionary bishop sent to Bavaria, Rupert had great successes in gaining converts along the Danube River. He requested permission to settle in Juvavum, a dilapidated Roman outpost. There he started the industry of salt mining in the mountains. This led to the rejuvenation of the area and its being renamed Salzburg. The monastery he erected is still in use today.

**Other patronages:** Salzburg

## MISSIONS / PETER CLAVER, 1580–1654, FEAST DAY: SEPTEMBER 9

A Spanish Jesuit, Peter went to the New World as a missionary. In Cartagena, Colombia, he was appalled at the plight of the thousands of slaves being brought in from Africa each month. He stayed for forty-four years as a "slave of the slave," meeting the slave boats and tending their human cargo as best he could. This made him the enemy of the slave traders and the upper classes. He was known as the prophet and miracle worker of Cartagena and is credited with saving that city from earthquake.

**Other patronages:** Colombia, Lake Charles (Louisiana); black missions, interracial justice, race relations; African-Americans

**Invoked:** against slavery

## MUSICIANS / CECILIA, D. 117, FEAST DAY: NOVEMBER 22

A girl from an illustrious Roman family, Cecilia was secretly a Christian. She had an arranged marriage with a pagan, and it is said that, on her wedding day, as the instruments were being played, Cecilia sang in her heart to God alone. After her marriage, she convinced her husband to follow her ways. He was found out and executed. When the Romans tried to behead her in her own home, she took three days to die. Her house became one of the first Christian churches. Some legends credit Cecilia with the invention of the organ.

**Other patronages:** composers, makers of musical instruments, poets

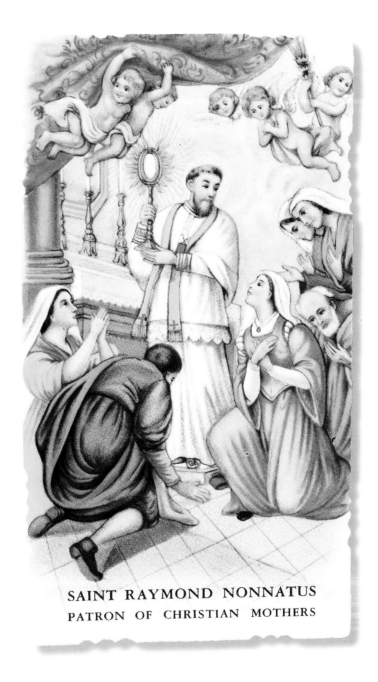

**SAINT RAYMOND NONNATUS**
PATRON OF CHRISTIAN MOTHERS

## OBSTETRICIANS / RAYMOND NONNATUS, 1204–1240, FEAST DAY: AUGUST 31

A Mercedarian monk from Spanish nobility, Raymond spent his fortune paying ransom for Christian captives in Algeria. When his funds ran out, he offered himself in place of the last one. To keep him from preaching, his captors put an iron padlock through his lips. He was ransomed back to Spain after eight months. His surname means "not born"; Raymond was delivered by cesarean section while his mother died. This made him particularly sympathetic to pregnant women.

**Other patronages:** Catalonia (Spain); midwives; childbirth, expectant mothers, falsely accused people, newborns

**Invoked:** against fever, perjury

K. BEURON 1066                    MADE IN GERMANY

## PHILOLOGISTS / HILDEGARD OF BINGEN, 1098–1179, FEAST DAY: SEPTEMBER 17

An abbess living on the banks of the Rhine, Hildegard of Bingen is considered one of the greatest minds of the twelfth century. She was a poet, composer, prophetess, and physician, equally at home in the arts and sciences. Her compositions are widely performed today. An adviser to popes, emperors, and other abbots and abbesses, Hildegard credited a mystical episode that occurred at the age of forty-two when she was infused with divine understanding of all she read and saw.

372      VLA

S. Justinus Martyr

## PHILOSOPHERS / JUSTIN MARTYR, 100–165, FEAST DAY: JUNE 1

Born in Palestine to Greek parents, Justin was the first Christian philosopher. As a young man, he studied the Stoics, the Pythagoreans, and the Platonists, and he was introduced to Christianity at the age of thirty-three. Seeing no conflict between faith and reason, he traveled widely, debating those of different faiths and philosophies. When he won an argument against a Cynic in Rome, he was arrested and beheaded.

**Other patronages:** apologists, lecturers, orators

✢

Sainte Christine.

## PSYCHIATRISTS / CHRISTINA THE ASTONISHING, 1150–1224, FEAST DAY: JULY 24

An orphan from Liege, Belgium, Christina was thought to have died from a seizure. In the middle of her funeral mass, she rose up and levitated to the church ceiling. Ordered down by the priest, she gave a detailed account of her visits to heaven, hell, and purgatory. Thought to be insane, she had an acute sense of smell and found it unbearable to be near many people. As she advanced in age, she gained respectability. Many Church officials consulted her on her visions.

**Other patronages:** mental illness; mental-health caregivers, therapists

✢

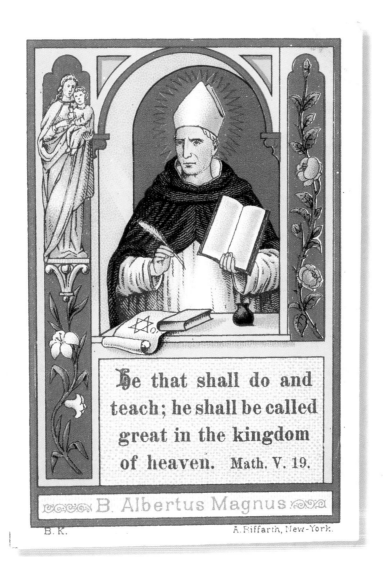

He that shall do and teach; he shall be called great in the kingdom of heaven. Math. V. 19.

B. Albertus Magnus

B. K.                    A. Riffarth, New-York.

SCIENTISTS / ALBERT THE GREAT, 1206–1280, FEAST DAY: NOVEMBER 15

Known as the "Universal Teacher," Albert resigned his post as bishop of Regensburg to concentrate on scientific teaching and research. He wrote encyclopedic volumes on biblical and theological subjects as well as physics, metaphysics, astronomy, chemistry, biology, geology, geometry, and botany. A scholar in the mode of Aristotle, he was one of the greatest minds of his day.
**Other patronages:** World Youth Day; medical technicians, philosophers, students

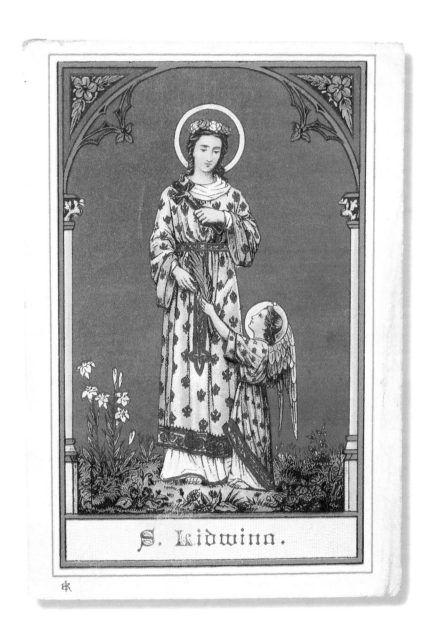

S. Lidwina.

## SKATERS / BLESSED LYDWINA OF SCHIEDAM, 1380–1433, FEAST DAY: APRIL 14

A beautiful girl from the Netherlands, Lydwina became an invalid due to an ice skating accident. For the next thirty years she endured agonizing body pain as well as a series of disfiguring illnesses. She devised a system of meditative prayer, in which she concentrated on Christ's suffering and offered up her own. Eventually, she fell into mystical experiences and her holiness served as an example to others.

**Other patronages:** skiers

✝

Les Saints Modèles de l'Enfance

St François Régis.

## SOCIAL WORKERS / JOHN REGIS, 1597–1640, FEAST DAY: JUNE 16

A Jesuit missionary in the Languedoc region of France, John Regis was known for his ability to reach common people. In each district he visited, he would send letters to the rich listing six poor individuals in need, with a monetary amount they should donate. By appealing to rich and poor alike, he got real results. He opened lace and embroidery factories as an alternative trade for prostitutes. Always working in primitive conditions, he died of pneumonia in the Pyrenees.

**Other patronages:** lace makers; illegitimate children

☩

VLA 431

## TEACHERS / JOHN BAPTIST DE LA SALLE, 1651–1719, FEAST DAY: APRIL 7

Giving up a life of ease as canon of Rheims, John Baptist devoted his life to the education of the poor. He donated his personal fortune to create a school to educate teachers. He was the founder of the Christian Brothers, an order devoted to the education of boys. There was much animosity toward his revolutionary teaching methods; he instituted the system of eight grades for primary school that we use today.

**Other patronages:** school principals

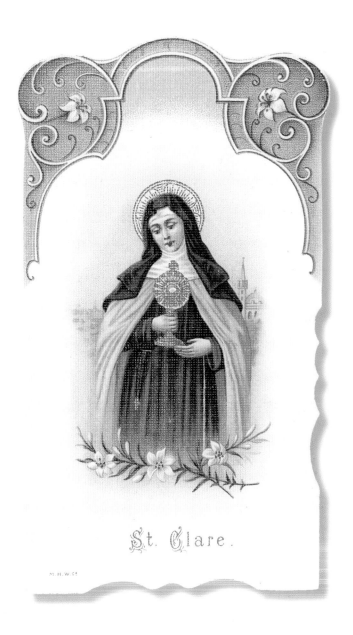

St. Clare.

## TELEVISION WORKERS / CLARE OF ASSISI, 1194–1255, FEAST DAY: AUGUST 11

Founder of her own order of nuns, together with Saint Francis, Clare challenged the religious authorities of their day by leading a youthful resurgence of spirituality, embracing poverty and simplicity. A mystic, Clare viewed midnight mass one Christmas from her bed and was able to correctly recount all the details of the service. This made her the patron of television.

**Other patronages:** telegraphs, telephones; embroiderers, gilders, needle workers
**Invoked:** against eye disease

✝

# Saints of
# States of Life

abandoned people: Flora of Cordoba, Germaine Cousin, Ivo of Kermartin, Jerome Emiliani, Pelagiu<br>
adopted children: Clotilde, Thomas More, William of Rochester babies: Brigid of Ireland, Holy Innocents<br>
Nicolas of Tolentino, Philip of Zell, Philomena, Raymond Nonnatus, Zeno of Verona bachelors: Benedic<br>
Joseph Labre, Benezet, Boniface of Tarsus, Caesarius of Nanzianzen, Casimir, Christopher, Cuthman<br>
Epipodius, Gerald of Aurillac, Guy of Anderlecht, John Rigby, Joseph Moscati, Luke the Apostle, Marinus<br>
Panteleon, Roch, Serenus the Gardener, Theobald barrenness: Agatha, Anne, Anthony of Padua, Casilda<br>
of Toledo, Felicity, Fiacre, Francis of Paola, Giles, Henry II, Margaret of Antioch, Medard, Philomena, Rita<br>
of Cascia, Theobald Roggeri betrayal victims: Epipodius, Flora of Cordoba, Oswin, Philip Howard, Pulcheria<br>
boys: Dominic Savio, John Bosco, Nicholas of Myra breastfeeding: Giles brides: Adelaide, Blaesilla<br>
Catherine of Genoa, Clotilde, Delphina, Dorothy of Caesarea, Dorothy of Montau, Elizabeth of Hungary<br>
Elizabeth of Portugal, Hedwig, Ida of Herzfeld, Ivetta of Huy, Margaret the Barefooted, Nicholas of Myra<br>
bridegrooms: Louis IX, Nicholas of Myra captives: Adelaide, Barbara, Beatrice da Silva Meneses, Charle<br>
of Blois, Daniel of Padua, Dismas, Dominic of Silos, Faith, Ferdinand III of Castile, Jacinta Marto, Joan o<br>
Arc, Joseph Cafasso, Leonard of Noblac, Louis IX, Mark the Evangelist, Maximilian Kolbe, Medard<br>
Nicholas of Myra, Vincent de Paul, Walter of Pontnoise chastity: Agnes of Rome, Thomas Aquinas chile<br>
abuse victims: Alodia, Germaine Cousin, Lufthild, Nunilo childbirth: Erasmus, Gerard Majella, Leonard o<br>
Noblac, Lutgardis, Margaret of Antioch, Raymond Nonnatus childless people: Anne Line, Catherine o<br>
Genoa, Gummarus, Henry II, Julian the Hospitaller children: Bathild, Gabriel Gowdel, Gerard Majella<br>
Maria Goretti, Nicholas of Myra, Pancras, Philomena, Raymond Nonnatus, Solange, Symphronian o<br>
Autun, Trophimus of Arles children learning to walk: Zeno of Verona converts: Afra, Alban, Anne Line<br>
Boniface of Tarsus, Caedwalla, Charles Lwanga, Edwin, Flora of Cordoba, Genesius of Rome, Helena<br>
Hermengild, John the Baptist, Joseph of Palestine, Lucian, Ludmila, Marcian, Margaret Clitherow, Mary<br>
Magdalene, Natalia, Olga, Philemon, Theodota, Vladimir I of Kiev death of children: Angela of Foligno<br>
Clotilde, Concepcion Cabrera de Armida, Cyriacus of Iconium, Dorothy of Montau, Elizabeth of Hungary<br>
Elizabeth Ann Seton, Felicity, Frances of Rome, Hedwig, Isidore the Farmer, Joaquina Vedruna de Mas<br>
Julitta, Leopold the Good, Louis IX, Luchesius, Margaret of Scotland, Marguerite d'Youville, Matilda<br>
Melania the Younger, Michelina of Pesaro, Nonna, Stephen of Hungary desperate situations: Jud<br>
Thaddeus, Gregory Thaumaturgus, Philomena, Rita of Cascia difficult marriages: Castora Gabrielli<br>
Catherine of Genoa, Dorothy of Montau, Edward the Confessor, Elizabeth of Portugal, Fabiola<br>
Gengulphus, Godelieve, Gummarus, Hedwig, Helena, Louis IX, Margaret the Barefooted, Marguerit<br>
d'Youville, Monica, Nicolas of Flüe, Olaf II, Pharaildis, Philip Howard, Radegunde, Rita of Cascia, Theodore<br>
of Sykeon, Thomas More, Wilgefortis, Zedislava Berka disappointing children: Clotilde, Louise de Marillac<br>
Matilda, Monica divorced people: Fabiola, Guntramnus, Helena doubters: Joseph, Thomas the Apostle<br>
dying people: Abel, Barbara, Benedict, Catherine of Alexandria, James the Lesser, John of God, Joseph<br>
Margaret of Antioch, Michael the Archangel, Nicholas of Tolentino, Sebastian dysfunctional families<br>
Eugene de Mazenod engaged couples: Ambrose Sansedoni of Siena, Valentine of Rome expectan<br>
mothers: Anne, Anthony of Padua, Dominic of Silos, Elizabeth, Gerard Majella, Joseph, Margaret o<br>
Antioch, Raymond Nonnatus, Ulric exiles: Adelaide, Angela Truszkowska, Arthelais, Clotilde, Elizabeth o<br>
Hungary, Jeanne Marie de Maille, Joaquina Vedruna de Mas, Kateri Tekakwitha, Margaret of Antioch<br>
Melania the Younger, Pulcheria, Rose of Viterbo falsely accused people: Blandina, Dominic de Guzman<br>
Dominic Savio, Elizabeth of Hungary, Elizabeth of Portugal, Gerard Majella, Helen of Skofde, Margaret<br>
of Antioch, Margret of Cortona, Marinus, Matilda, Menas Kallikelados, Philip Howard, Raymond<br>
Nonnatus, Roch, Serenus the Gardener famine: Walburga fathers: Joachim, Joseph first communicants<br>
Imelda Lambertini, Pope Pius X, Tarsicius girls: Agnes of Rome, Blandina, Catherine of Alexandria, Irene<br>
Maria Goretti grandfathers: Joachim grandmothers: Anne guardians: Guntramnus, Joseph of Palestine<br>
Mamas gypsies: Sarah hanged men: Colman of Stockerau happy marriages: Valentine of Rome happy<br>
meetings: Raphael the Archangel homeless people: Benedict Joseph Labre, Edwin, Elizabeth of Hungary<br>
Lufthild, Margaret of Cortona house hunting: Joseph illegitimate children: Brigid of Ireland, Eustochium<br>
of Padua, Sibyllina Biscossi immigrants: Frances Xavier Cabrini, Joseph injustice: Nicholas of Tolentino in<br>
law problems: Adelaide, Elizabeth of Hungary, Elizabeth Ann Seton, Godelieve, Helen of Skofde, Jeanne<br>
de Chantal, Jeanne Marie de Maille, Ludmila, Marguerite d'Youville, Michelina, Pulcheria invalids: Roch<br>
jealousy: Elizabeth of Portugal, Hedwig juvenile delinquents: Dominic Savio kidnap victims: Arthelais<br>
Dagobert II, Simon of Trent, Wernher, William of Norwich lawsuits: Agia learning: Acca, Ambrose o<br>
Milan, Margaret of Scotland, Nicholas Albergati, Thomas Aquinas loneliness: Rita of Cascia longevity<br>
Peter the Apostle lost keys: Zita lost objects: Anne, Anthony of Padua, Antony of Pavoni, Arnulf o<br>
Soissons, Daniel of Padua, Phanurius, Vincent de Paul lost vocations: Gotteschalk, James Intercisus

✠

Luchesius lovers: Dwynwen, Raphael the Archangel, Valentine of Rome married women: Monica misfortune: Agricola of Avignon, Honoratus of Arles mothers: Anne, Gerard Majella, Monica native rights: Turibius of Mogrovei nightmares: Raphael the Archangel nursing mothers: Concordia, Martina oaths: Pancras one-armed people: John Damascene oppressed people: Anthony of Padua orphans: Agnes of Rome, Aurelius, Dagobert II, Drogo, Frances Xavier Cabrini, Ivo of Kermartin, Jerome Emiliani, Mamas, Pulcheria oversleeping: Vitus parents of large families: Adalbald of Ostrevant, Adelaide, Clotilde, Dagobert II, Dorothy of Montau, Edwin, Ferdinand III of Castile, Ivetta of Huy, Leonidas of Alexandria, Leopold III, Louis IX, Margaret of Scotland, Matilda, Nicholas of Flüe, Richard Gwyn, Thomas More, Vladimir I of Kiev peace: Barnabas, Elizabeth of Portugal, Francis of Assisi, Irene, Norbert perjury: Felix of Nola, Pancras physical abuse victims: Adelaide, Agostina Pietrantoni, Fabiola, Germaine Cousin, Godelieve, Jeanne de Lestonnac, Jeanne Marie de Maille, Joaquina Vedruna de Mas, Laura Vicuna, Margaret the Barefooted, Maria Bagnesi, Monica, Pharildis, Rita of Cascia pregnancy: Anne, Anthony of Padua, Dominic of Silos, Elizabeth, Gerard Majella, Joseph, Margaret of Antioch, Raymond Nonnatus, Ulric political imprisonment: Maximilian Kolbe poor people: Anthony of Padua, Ferdinand III of Castile, Giles, Lawrence, Martin de Porres, Nicholas of Myra, Philomena, Zoticus of Constantinople possessed people: Amabilis, Bruno, Cyriacus, Denis, Dymphna, Lucian, Lucy Bufalari, Marcian, Margaret of Fontana, Quirinus, Ubaldus Baldassini poverty: Agostina Petratoni, Anne, Armogastes, Bernadette of Lourdes, Cuthman, Germaine Cousin, Julia Billiart, Macrina the Elder, Marguerite Bourgeous, Margaret of Castello, Maria Fortunata Viti, Maria Gabriella, Maria Goretti, Marie of the Incarnation, Martin of Tours, Pauline-Marie Jaricot, Regina, Saturus racial harmony: Martin de Porres, Peter Claver rape victims: Agatha, Agnes of Rome, Antonia Mesina, Dymphna, Joan of Arc, Maria Goretti, Pierina Morosini, Potamiaena, Solange, Zita refugees: Alban rejected by religious orders: Benedict Joseph Labre, Clare of Assisi, Eugenie Smet, Henry II, Jeanne de Lestonnac, Joseph Moscati, Louise de Marillac, Margaret of Castello, Marguerite Bourgeous, Mary Ann de Paredes, Rose of Viterbo, Teresa de Gesu, Jornet y Ibars, Thecla Merlo retreats: Ignatius of Loyola robbery: Leonard of Noblac, Nicholas of Myra runaways: Alodia, Dymphna, Eulalia of Merida second marriages: Adelaide, Matilda separated from children: Jeanne de Chantal, Marie of the Incarnation separated spouses: Edward the Confessor, Gengulphus, Gummarus, Nicholas of Flüe, Philip Howard shipwreck victims: Anthony of Padua, Jodocus single laywomen: Agatha, Alodia, Bibiana, Emiliana, Flora of Cordoba, Gudule, Julitta, Margaret of Cortona, Martha, Nunilo, Praxides, Syncletica, Trasilla, Zita slander: John Nepomucene slavery: Peter Claver sleepwalkers: Dymphna social justice: Joseph, Martin de Porres spinsters: Andrew the Apostle, Catherine of Alexandria, Nicholas of Myra Spiritual Exercises: Ignatius of Loyola stepparents: Adelaide, Leopold III, Thomas More strife: Denis success: Servatus teenagers: Aloysius Gonzaga temptation: Angela of Foligno, Benedict, Catherine of Bologna, Catherine of Genoa, Catherine of Siena, Columba of Rieti, Cyriacus, Elizabeth of Schonau, Eustochium of Padua, Gemma Galgani, Helen del Cavalcanti, Margaret of Cortona, Maria Fortunata Viti, Michael the Archangel, Syncletica torture victims: Agatha, Alban, Armogastes, Bibiana, Blandina, Charles Lwanga, Cyriacus of Iconium, Edmund of East Anglia, Epipodius, Eulalia of Merida, Eustachius, Gensius of Rome, Hugh the Little, James Intercisus, John Rigby, Julia of Corsica, Julitta, Mamas, Margaret Ward, Panteleon, Pelagius, Regina, Richard Gwyn, Sabas, Simon of Trent, Theodota, Victor of Marseilles, William of Norwich unattractive people: Drogo, Germaine Cousin unfaithfulness: Catherine of Genoa, Elizabeth of Portugal, Fabiola, Gengulphus, Marguerite d'Youville, Monica unhappy marriages: Castora Gabrielli, Catherine of Genoa, Dorothy of Montau, Edward the Confessor, Elizabeth of Portugal, Fabiola, Gengulphus, Godelieve, Gummarus, Hedwig, Helena, Louis IX, Margaret the Barefooted, Marguerite d'Youville, Monica, Nicholas of Flüe, Olaf II, Pharaildis, Philip Howard, Radegunde, Rita of Cascia, Thomas of Sykeon, Thomas More, Wilgefortis, Zedislava Berka vanity: Rose of Lima virgins: Agnes of Rome war: Elizabeth of Portugal widowers: Edgar the Peaceful, Thomas More widows: Adelaide, Anastasia, Angela of Foligno, Anne Line, Bathild, Bridget of Sweden, Blaesilla, Castora Gabrielli, Catherine of Genoa, Clotilde, Concepcion Cabrera de Armida, Dorothy of Montau, Elizabeth of Hungary, Elizabeth of Portugal, Elizabeth Ann Seton, Etheldreda, Fabiola, Felicity, Frances of Rome, Hedwig, Helen del Cavalcanti, Helen of Skofde, Ida of Boulogne, Ida of Herzfeld, Ivetta of Huy, Jeanne de Chantal, Jeanne de Lestonnac, Jeanne Marie de Maille, Joaquina Vedruna de Mas, Julitta, Louise de Marillac, Lucy de Freitas, Ludmila, Macrina the Elder, Margaret of Scotland, Margaret the Barefooted, Marguerite d'Youville, Marie of the Incarnation, Matilda, Michelina, Monica, Olga, Paula, Pharaildis, Rita of Cascia wives: Monica women: Margaret of Antoich, Mary Magdalene youth: Aloysius Gonzaga, Gabriel of Our Lady of Sorrows, John Berchmans, John Bosco, Maria Goretti, Pedro Calungsod, Philomena, Raphael the Archangel, Stanislaus Kostka, Terese of the Andes, Valentine of Rome

**W**e all suffer hardships that can drastically change our social, economic, or physical situation. These changes might be temporarily endured, or they can last a lifetime. For the most part, saints with patronages extending over states of life have first-hand knowledge of losing children, wealth, or even limbs of their bodies. With grace, these holy people have transcended the personal hell of addictive behaviors, including alcoholism, drug addiction, and gambling. Among their ranks are reformed tormentors as well as victims of physical and mental abuse. Coming from every social class, they have lived both anonymously and notoriously, some suffering public ridicule, others honored with great acclaim. They all serve as role models for the entire family of humanity, accepting every life condition and finding hope in places where none is evident.

S. Germana.

Sancta Germana.

S. Germaine. H. Germana.

## ABANDONED PEOPLE / GERMAINE COUSIN, 1579–1601, FEAST DAY: JUNE 15

Born to a poor farm family near Toulouse, France, Germaine was a sickly, ugly child with a withered arm. After her mother died, her father married a woman who was especially cruel to Germaine, forcing her to live in a stable and tend sheep. She made a rosary out of string, and when she left her sheep to attend mass, no harm from wolves ever came to them. She died on her pallet, and forty years after her death, when her body was accidentally exhumed, it was found to be incorrupt. Hundreds of miracles have been reported due to her intercession.

**Other patronages:** shepherdesses; abuse victims, handicapped people, unattractive people
**Invoked:** against poverty

S. Chlotildis.

## ADOPTED CHILDREN / CLOTILDE, 475–545, FEAST DAY: JUNE 3

A Christian princess from Burgundy, Clotilde married the king of the Franks and converted him to Christianity. After his death, her three sons fought amongst themselves and her daughter was forced into a terrible marriage. She adopted her three grandsons after the murder of their father. Two of these children were murdered by their uncles; the third, she safely hid in a monastery. She retired to Toulouse to escape these events and worked among the poor for the rest of her life.

**Other patronages:** queens; brides, death of children, disappointing children, exiles, widows

‡

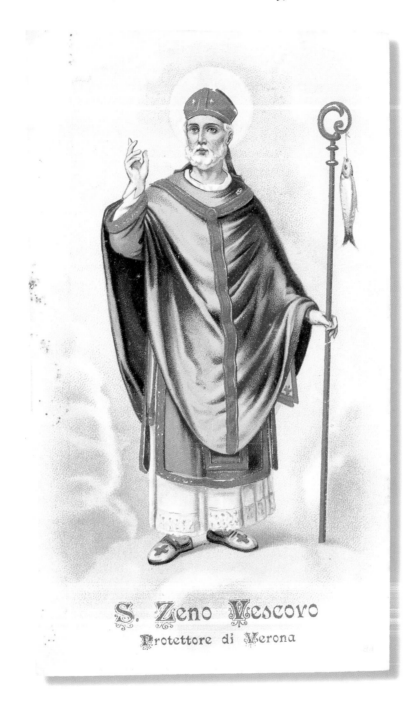

S. Zeno Vescovo

Protettore di Verona

## BABIES / ZENO OF VERONA, 300–371, FEAST DAY: APRIL 12

Born in Africa, Zeno was a bishop of Verona who loved to fish in the Adige river. He was a notable preacher and wrote much about baptism. When he was born, a demon took his place in his crib, and though he was suckled for eighteen years, he never grew. In the meantime, Zeno was raised by monks. When he was coincidentally sent by them to investigate this phenomenon, he forced the demon to spit up all the milk he had consumed into a great vat.

**Other patronages:** Verona; fishermen; children learning to speak, children learning to walk

✝

S. MARTINA V.M.

Nr. 390                                        VLA

BREASTFEEDING / MARTINA, D. 228, FEAST DAY: JANUARY 30

A Roman noblewoman who converted to Christianity after being orphaned, her remains were discovered in the seventeenth century. Martina was said to have been tortured for days, and when she was executed with a sword, milk flowed from her body instead of blood. A church was built for her in the Roman Forum.

**Other patronages:** Rome

## BRIDES / ADELAIDE, 931–999, FEAST DAY: DECEMBER 16

The daughter of the king of Burgundy, Adelaide was forced into an arranged marriage with Lothar of Italy at the age of fifteen. He died after three years, and she eventually married Otto the Great of Germany. They had four children, and upon his death, her daughter-in-law turned her son against Adelaide, forcing her into exile. She returned to raise her grandson after his parents' death, resuming her life of founding monasteries and tending the poor upon his accession.

**Other patronages:** empresses; abuse victims, exiles, parenthood, parents of large families, prisoners, second marriages, stepparents, widows

**Invoked:** against in-law problems

✠

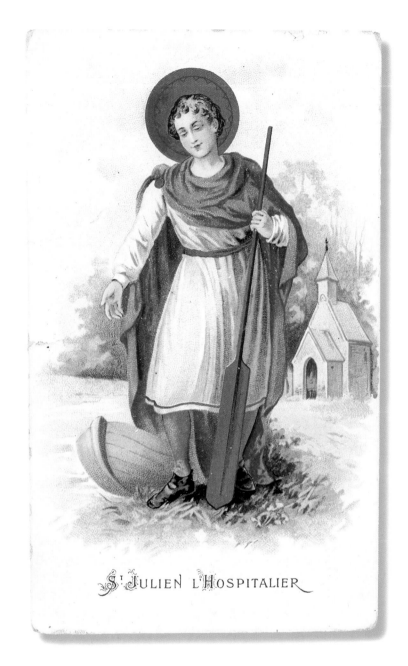

S<sup>T</sup> JULIEN L'HOSPITALIER

**CHILDLESS PEOPLE / JULIAN THE HOSPITALLER, DATES UNKNOWN, FEAST DAY: FEBRUARY 12**

A noble layman, Julian was out hunting when a stag warned him that one day he would kill his own parents. To avoid this fate, he moved far away and married. After years of searching, his parents located him and went to surprise him. Returning to his house, he saw two figures in bed. Thinking his wife was with another man, he killed them. Turning back the covers, he saw it was his parents. He and his wife then gave up everything and went on a pilgrimage. Julian did penance, helping the poor and opening a sanctuary for lepers, until he earned divine forgiveness.

**Other patronages:** hospitality; boatmen, circus workers, clowns, fiddlers, innkeepers, jugglers, murderers, pilgrims, shepherds

**Invoked:** to find lodging while traveling

‡

**CONVERTS / AFRA, D. 304, FEAST DAY: AUGUST 5**

Her family was originally from Cyprus, and they settled in Augsburg, Germany. Afra was a follower of the goddess Venus and ran a brothel in her name. During the Diocletian persecutions, a fleeing bishop hid there, converting Afra, her employees, and her family. When she refused to renounce the bishop or her faith to the authorities, she was burned to death. Her mother and three of her servants suffered the same fate.

**Other patronages:** Augsburg (Germany); martyrs, penitent women; medicinal herbs

✠

*Santi Quirico e Giulitta*
*Martiri*

### DEATH OF CHILDREN / JULITTA AND CYRIACUS OF ICONIUM, D. 304, FEAST DAY: JUNE 16

A Turkish widow, Julitta and her young son, Cyriacus, moved to Tarsus to escape persecution. She was denounced to a ruling magistrate there, who questioned her while he played with Cyriacus. When she refused to give up her faith, she was given the death sentence. Her son told the magistrate he was a Christian as well, so enraging the man that he threw the boy down the stairs, killing him before his mother. Centuries later, Cyriacus appeared to the Emperor Charlemagne, who was in danger of being gored by a boar while hunting. He offered to save the emperor in exchange for clothing for himself. He is known as Saint Cyr in France.

**Other patronages:** torture victims

✝

Hl. Philomena.

Stark im Schwachen, groß im Kleinen,
Ist der Glaube, gottgegeben;
Selig sind die Herzensreinen:
Gott sie schaun im ew'gen Leben.

Commissariat of the Holy Land Washington, D.C.

## DESPERATE SITUATIONS / PHILOMENA, DATES UNKNOWN, FEAST DAY: AUGUST 11

In 1802, the tomb of a thirteen-year-old girl was found in the catacombs, with the carved words "Peace be with you, Philomena." Also carved were the symbols of virginity and martyrdom. When these relics of this unknown martyr were taken to the Vatican, they were transferred to a church in Naples by a priest who felt a spiritual message from them. After several miracles were reported because of them, a cult grew around Philomena. Among her devotees were many future saints of the Catholic Church and several popes.

**Other patronages:** barrenness; Children of Mary, the Living Rosary; priests; children, poor people

☩

S. CATERINA DI GENOVA
Ritratto autentico il cui originale trovasi nella sua stanza
all'ospedale di Pammatone

## DIFFICULT MARRIAGES / CATHERINE OF GENOA, 1447–1510, FEAST DAY: SEPTEMBER 15

Born into Genoese nobility, Catherine was married to a rival family's son. Her husband was an unfaithful spendthrift who reduced them to bankruptcy. He frequently complained about Catherine's shrewish behavior. Estranged from each other, they had no children. Ten years into their marriage, Catherine experienced a blinding ray of light that completely changed her life. She converted her husband and they devoted themselves to tending the sick and the poor. Catherine's mystical writings on purgatory are well known.

**Other patronages:** brides, childless people, those ridiculed for piety, victims of adultery, widows
**Invoked:** against temptation

✠

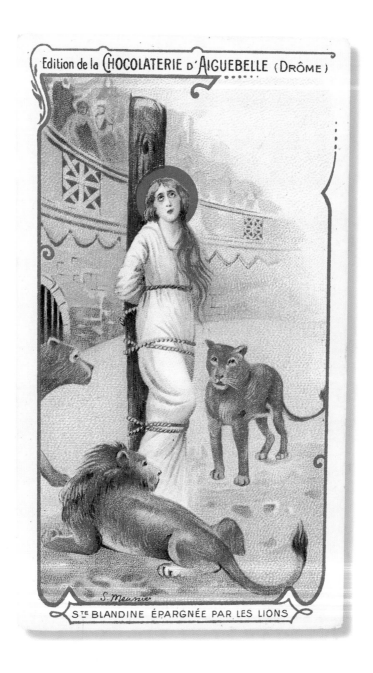

Edition de la CHOCOLATERIE D'AIGUEBELLE (DRÔME)

Ste BLANDINE ÉPARGNÉE PAR LES LIONS

## FALSELY ACCUSED PEOPLE / BLANDINA, D. 177, FEAST DAY: JUNE 2

A slave girl converted by the Christian family she worked for, Blandina was imprisoned during a persecution in Lyons, France. Under torture, she refused to agree with charges accusing Christians of committing incest and cannibalism. Condemned to die in the arena, the lions and bears did not touch her as she comforted her dying compatriots. She was then tied in a net and gored to death by a wild bull, her body burned, and her ashes thrown in the river.

**Other patronages:** girls, torture victims

✠

vidi G. Keusens. I.C.                        Boek en Steend. K. v. d. Vyvere-Petyt Brugge.

**Laat ons Joachim loven, roemrijk in zijn nageslacht.**

### GRANDFATHERS / JOACHIM, FIRST CENTURY B.C., FEAST DAY: JULY 26

Married to Saint Anne, and father of the Virgin Mary, Joachim prayed for twenty years to have children. After Mary was born, he kept the promise he made and allowed her to be raised by the temple priests from the age of three. He is Christ's earthly grandfather.
**Other patronages:** Adjuntas (Puerto Rico); fathers

‡

Sanctus Benedictus-Labre.

Sté St Augustin      65.      Déposé 1885. A. b.

## HOMELESS PEOPLE / BENEDICT JOSEPH LABRE, 1748–1783, FEAST DAY: APRIL 16

Born into a prosperous middle-class family in Boulogne, France, Benedict Joseph attempted to enter three different religious orders: the Trappists, the Carthusians, and the Cistercians. Denied entrance because of his health, he went on a barefoot pilgrimage to all the Christian shrines in Europe. Intending to live as a hermit out in the world, he depended on divine providence for his meals and slept in the streets. He died seven years later on the steps of a Roman church.

**Other Patronages:** mental illness; beggars, pilgrims; bachelors, people rejected by religious orders

‡

S. NICOLA DA TOLENTINO AGOSTINIANO

## INJUSTICE / NICHOLAS OF TOLENTINO, 1245–1305, FEAST DAY: SEPTEMBER 10

Born in Umbria, Italy, Nicholas was a preacher known for working miracles. When he was born, and again in the year before his death, a star was seen wherever he went. He was a peacemaker in a town torn by political strife. Nicholas worked with the poor and with prisoners, many of whom he worked to free. He was especially devoted to praying for the recently dead and the souls in purgatory.

**Other patronages:** Cordoba (Spain), Lima; partridges, sick animals; boatmen; babies, dying people, souls in purgatory, women in labor

**Invoked:** against fever, fire, thunderstorms, pestilence

☩

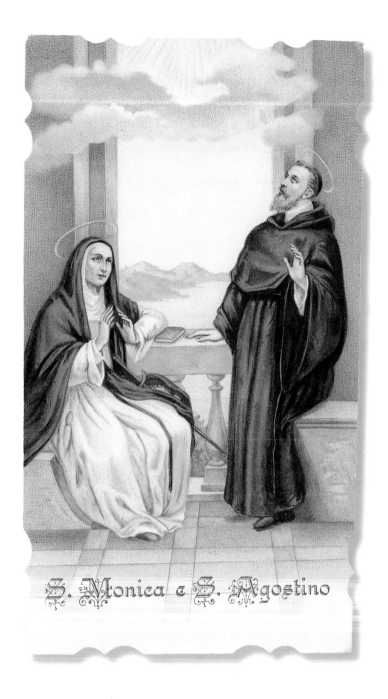

S. Monica e S. Agostino

**MARRIED WOMEN / MONICA, 331–387, FEAST DAY: AUGUST 27**

Born as a Christian in Algeria and living with a pagan husband in Carthage, Monica had a difficult marriage. Her husband was abusive and her mother-in-law disliked her. Monica was a reformed alcoholic when she followed her pleasure-loving son, Augustine, to Italy. She was known for her tears and constant prayers for his conversion. After a wild life, he became one of the greatest saints of the Catholic Church. Monica died shortly after he became a Christian.

**Other patronages:** housewives; abuse victims, adultery victims, alcoholics, disappointing children, mothers

☩

Hl. Johannes v. Damaskus

Nr. 365          (27. März)          VLA

## ONE-ARMED PEOPLE / JOHN DAMASCENE, 676–749, FEAST DAY: MARCH 27

A Syrian Christian who was the chief financial officer for the Muslim caliph, John was extremely well educated. When the patriarch of Constantinople ordered the destruction of icons as graven images, John wrote the treatise *In Defense of Icons*. This brought the common people into the debate. In revenge, the patriarch made false charges against him to the caliph, and John's writing hand was cut off as punishment. He spent the night praying before an icon of the Virgin Mary, and it was miraculously reattached. He is one of the Doctors of the Church.

**Other patronages:** iconographers

✢

SANCTUS NORBERTUS O.P.D.

VIDI E. REUSENS J C          CAALS & SCHNEIDER EDIT. ANVERS

## PEACE / NORBERT, 1080–1134, FEAST DAY: JUNE 6

A German noble devoted to pleasure, Norbert took holy orders as a career move. When the horse he was riding was hit by lightning, Norbert awoke in a ditch a changed man. He became a traveling preacher, donated his wealth to the poor, and founded a movement of laypeople dedicated to reforming monasteries throughout Europe. He tried to settle a schism in the Church between Pope Innocent II and the antipope Anacletus.

**Other patronages:** Bohemia, Magdeburg (Germany)

✢

Die hl. Godoleva, Martyrin.

Dép 3928

## Physical Abuse Victims / Godelieve, 1049–1070, Feast Day: July 6

A Flemish noblewoman with an arranged marriage, Godelieve was considered ugly by her new husband and mother-in-law. She was deserted by him and was locked in a cell, starved and beaten by her in-laws. The local bishop made her husband return to the marriage, but her husband had Godelieve strangled and drowned in a pond. Local people considered the site of her murder sacred, and there have been multiple reports of miraculous healing through her intercession.

**Other patronages:** healthy throats; difficult marriages, verbal abuse victims
**Invoked:** against throat diseases

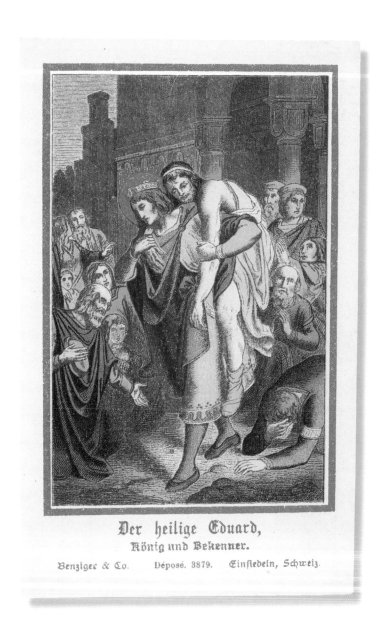

Der heilige Eduard,
König und Bekenner.

Benziger & Co.     Déposé. 3879.     Einsiedeln, Schweiz.

**SEPARATED SPOUSES / EDWARD THE CONFESSOR, 1003–1066, FEAST DAY: OCTOBER 13**

Called "the Confessor" because he was a witness to his faith, Edward came out of exile to become the last Anglo-Saxon king of England. During his reign, his country enjoyed twenty years of peace. Edward and his wife, Edith, had no children since they were said to be celibate. Edward was generous to the poor, distributing rings as gifts. He had the power to heal, and he built Westminster Abbey in lieu of going on a much-desired pilgrimage to Rome.

**Other patronages:** England; kings; difficult marriages

‡

Déposé »St. Norbertus«, Wien. — Mit kirchl. Genehmigung.

St. Leopold.

## STEPPARENTS / LEOPOLD III, 1073–1136, FEAST DAY: NOVEMBER 15

The military governor of Austria, Leopold married Agnes, daughter of the emperor. She was a widow with two children, whom he raised. He and Agnes had an additional eighteen children, eleven of whom survived childhood. Refusing the crown of the Holy Roman Empire, Leopold founded Benedictine, Cistercian, and Augustinian monasteries, developing new towns and cities in Austria.

**Other patronages:** Austria; death of children, large families

‡

## STRIFE / DENIS, D. 258, FEAST DAY: OCTOBER 9

An early missionary, Denis was the first bishop of Paris. The Roman governor had him and two companions tortured by flogging and roasting. When Denis would not die, they chopped off his head on what is now called Montmartre ("Hill of Martyrs"). When he picked up his own head and carried it six miles to his present burial place, many were converted.

**Other patronages:** headaches, rabies; France, Paris; Royal House of France; possessed people
**Invoked:** against frenzy, syphilis

☦

S. Benedictus

2085                                                    CASM

## TEMPTATION / BENEDICT, 480–547, FEAST DAY: JULY 11

While a student in Rome, Benedict ran from the city to escape its temptations. He lived in a cave for three years, working and praying. The Devil came in many guises to tempt him, but he escaped by throwing himself into thorn bushes. Benedict is the founding father of Western monasticism. For centuries, his monasteries protected knowledge in the arts, sciences, medicine, and agriculture while Europe declined into the so-called Dark Ages.

**Other patronages:** Europe, Nursia (Italy), Palermo (Italy), Subiaco (Italy); agricultural workers, builders, civil engineers, coppersmiths, schoolchildren, speleologists; dying people

**Invoked:** against fever, gallstones, kidney diseases, poisoning

✠

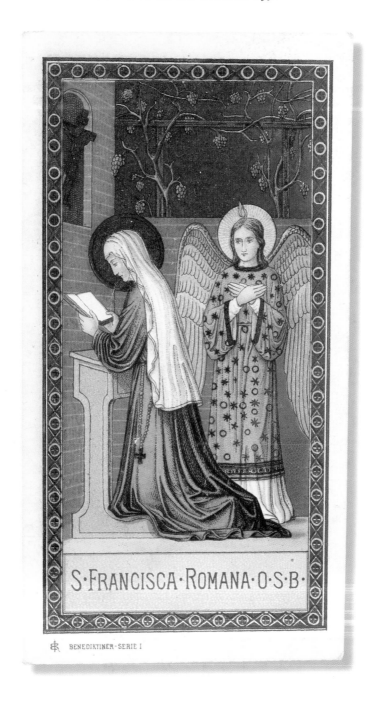

S·FRANCISCA·ROMANA·O·S·B·

BENEDIKTINER-SERIE I

## WIDOWS / FRANCES OF ROME, 1384–1440, FEAST DAY: MARCH 9

A noble Roman woman, Frances had a happy forty-year marriage. Though she lived in a palazzo, she organized a group of laywomen to help tend the sick. The city was in great political turmoil, and her husband was exiled, leaving her to manage alone. The family lost much of its fortune, and on his return, he died a broken man. Through prayer and a cheerful disposition, Frances was granted the privilege of always seeing her guardian angel, whose glow functioned much like a headlight on a car. After her husband's death, Frances entered religious life.

**Other patronages:** motorists, taxi drivers; death of children

‡